WITHDRAWN

ON PAPER

Jane Thomas and Paul Jackson

MERRELL

in association with the
Crafts Council

This book has been produced to accompany the exhibition
On Paper: New Paper Art

at

Crafts Council Gallery
44a Pentonville Road
Islington
London N1 9BY

5 July – 2 September 2001

First published in 2001 by Merrell Publishers Limited

Distributed in the USA and Canada by Rizzoli International Publications, Inc.
through St Martin's Press, 175 Fifth Avenue, New York, New York 10010

British Library Cataloguing-in-Publication Data:
Thomas, Jane
On paper : new paper art
1.Paper art 2.Paper art – History
I.Title
745.5'4

ISBN 1 85894 145 8

Produced by Merrell Publishers Limited
42 Southwark Street
London SE1 1UN
www.merrellpublishers.com

Designed by Karen Wilks
Edited by Iain Ross

Printed and bound in Italy

Front cover: Charlie Thomas, *Womens- and Menswear Autumn/Winter 1999/2000*, 1999 (see pp. 70–71)
Back cover: top left: Jennie Farmer, *Folded Book*, 2000 (see p. 39); top right: Eric Joisel, *Hedgehog*, 1999 (see p. 57); bottom left: Lois Walpole, commission for the Co-op Headquarters, Rochdale, 1997 (see p. 89); bottom right: Kaarina Kaikkonen, *My Outline*, 1997 (see p. 107)
Page 1: Vincent Floderer, *Boom*, 2000 (detail; see p. 58)
Frontispiece: Jennie Farmer, *Folded Book*, 2000 (detail; see p. 39)

THE
**ARTS
COUNCIL**
OF ENGLAND

CONTENTS

FOREWORD AND ACKNOWLEDGEMENTS 7

INTRODUCTION 8

ON PAPER: JANE THOMAS 11

ABOUT PAPER: PAUL JACKSON 27

SECTION ONE: TEXT AND MESSAGE 32

SECTION TWO: NEW FOLDING 52

SECTION THREE: CUT AND CONSTRUCTED 68

SECTION FOUR: NATURE AND SPIRIT 90

GLOSSARY 110

INTERNATIONAL RESOURCES 113

PICTURE CREDITS 125

SELECTED BIBLIOGRAPHY 126

INDEX 128

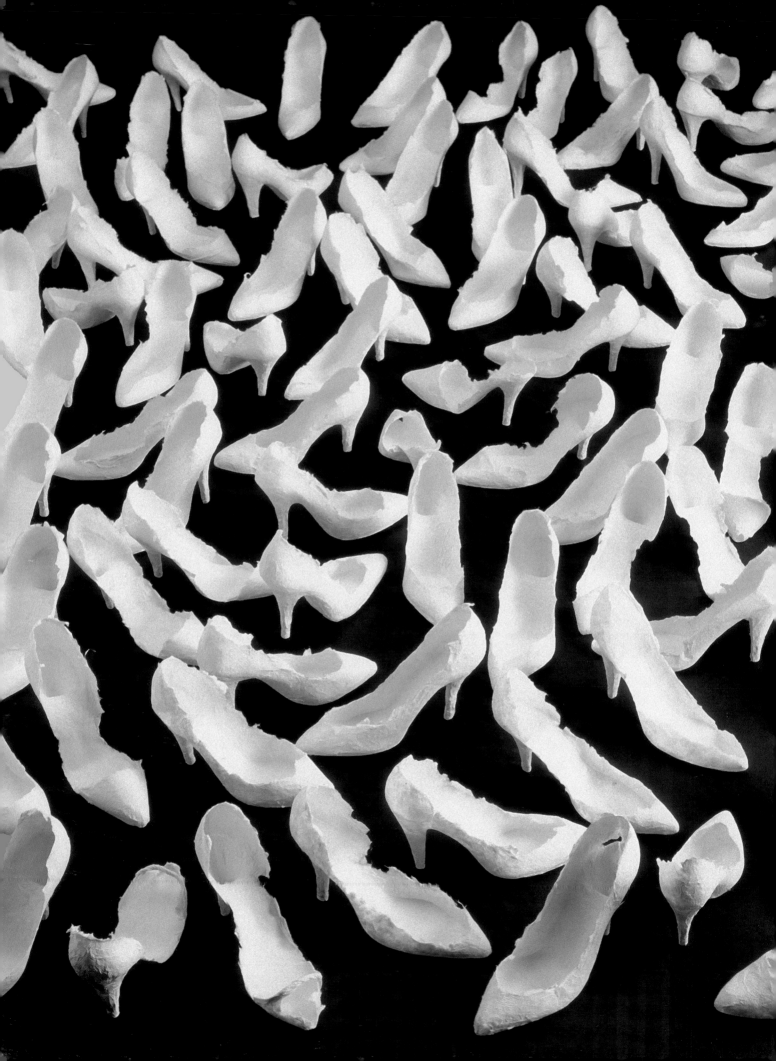

FOREWORD AND ACKNOWLEDGEMENTS

Outside specialist circles, the art of paper construction may seem limited to origami, a highly refined and ancient discipline, but popular also as a hobby – remember the water bombs of childhood games. Paul Jackson alerted our attention to the amazing developments going on in the field. His folded paper vessels exhibited in the Crafts Council exhibition *Contemporary International Basketmaking* in 1999/2000 caught the eye of a visiting tutor from the Architectural Association, who invited Jackson to tutor a short course on folded structures in architecture. 'Not just another stegosaurus', was Jackson's rallying cry, as he set about converting the Crafts Council exhibitions team to the idea of a survey exhibition of work in paper, showing us new work from around the world. While the feats of paper engineers have their own outlets and applications in packaging, advertising and pop-up books, it was the emergence of an international group of visual artists taking paper construction into new territory that signalled the need for a major exhibition. Sure to captivate visitors and readers alike, the objects included range from the sublime and magical to the humorous, as well as the substantial. On our side is the immediacy of paper as a material and our human response to its alchemical properties for transformation.

In the context of established disciplines such as studio ceramics and contemporary textiles, work in paper is a relatively new area of practice. One of the rôles of the Crafts Council's exhibitions programme is to seek out and champion just such new developments, providing stimulating examples, particularly from abroad, with a view to increasing the number of people involved and raising the level of awareness. In her first major curatorial project, Jane Thomas, Exhibitions Officer at the Crafts Council, has brought to the subject a personal passion, and has selected an intriguing and impressive range of work. Furthermore, as this publication demonstrates, she has repositioned paper forms within the broader field of the visual arts, identifying their affinity with traditional practices and the international fibre art movement, as well as contemporary sculpture in ephemeral materials.

Our warmest gratitude goes to the craftspeople and artists represented in the exhibition, and to those who, although not represented, have allowed the reproduction of their work in this catalogue. We wish them the greatest success in reaching new audiences. Special thanks go to Paul Jackson and Sophie Dawson for their contributions to the publication, and to Jacki Parry and Cas Holmes for their advice. We are grateful to Merrell Publishers for working with the Crafts Council on this publication, and in particular to Hugh Merrell and Julian Honer. I should like to thank our exhibition designers and NB: Studio for the design of publicity material. Finally, I should like to thank Jane Thomas for the curation of the exhibition and for the writing of this catalogue, and the colleagues who have supported and helped organize the project and the associated events.

Louise Taylor
Director of Exhibitions and Collection
Crafts Council
February 2001

INTRODUCTION

Take a piece of paper, fold and turn it in your hand, screwing it up to form a ball. The artist Martin Creed has based a career on creating ephemeral objects, art that is non-art; commenting and indeed contributing to an absurdity in the arena of the contemporary fine-art scene. His spherical ball of paper *Work #88: a sheet of A4 paper crumpled into a ball* (fig. 1) is a signature piece.

Whether a found scrap or pristine new leaf, paper as a material carries with it the suggestion of more than its physical materiality. It is perceived as basic, almost elemental matter, but it is, in fact, already a product, a manufactured substance invented to fulfil a purpose – many purposes. As such, it is a material 'on a promise': a pregnant pause, a held breath. Its history is integral to social, political, commercial and cultural development. What is often overlooked is that it is also a flexible, strong and easily manipulated material with its own aesthetic qualities beyond those that it may have accrued through its use as a support for other media. Indeed, as a material in its own right it is unique, not only in its substance, but also in the fact that it can carry these additional inferred meanings through its heritage and the histories of its invention and use.

1
Martin Creed
Work #88: a sheet of A4 paper crumpled into a ball, 1995
Paper
Diameter 5 cm

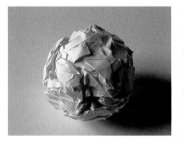

Paper has the potential to support anything from the most worthy literary work to a message on a telephone pad or the notes for this essay, which are now in the form of individual balled masterpieces 'after Creed', discarded and currently littering my feet. Creed's crumpled ball is a quickly but carefully crafted sculptural object, oddly spherical, with an aesthetic presence occupying and commanding the space in which it is placed. The reason that Creed's *Work #88* works as an art object is that it contains integrity in its material and resolution in its structure, and also an irony founded on our value systems. It alludes to its formation from an activity that most of us have performed without considered thought: it is an object that we have all created, never attributing to it any value whatsoever; it is made of the cheapest of materials; it has no significance. And yet it has the potential to be profound.

2
Paul Jackson
Single Crease Form, 1999
Paper
15 × 20 × 20 cm

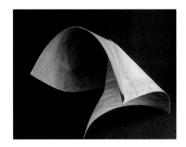

We can all relate to the simple pleasure of enfolding paper in the palm of the hand, even if, in most cases, it is to toss it into the waste-paper basket. *On Paper* explores this relationship by presenting paper not in its expected role as support on to which another media is to be applied, but as a material to be manipulated and formed. *On Paper*'s narrative follows the development and recognition of paper as a medium of expression. The artists brought together in this survey are diverse in their practice, but all share an enthusiasm for their chosen material. Although the paper-folding artist Paul Jackson (fig. 2) may not share the same conceptual aims as Martin Creed, both are aware of the instant

accessibility of a simple sheet of paper. Jackson is an enthusiastic ambassador for paper folding and paper sculpture, both as a grass-roots activity and at the highest level of creative endeavour. In this book he presents a personal reflection on the many uses of paper, from extraordinary sculptural constructions to its use in therapy and project work.

The accessible simplicity of paper folding, in hand with the desire to illustrate the breadth and diversity of practice, was the starting point for this project. While researching it, it quickly became apparent that the makers, artists and designers who use paper as their primary material feel a particular relationship with its nature, the histories of its use and the symbolism it has attained in different cultures. Such paper-folding artists as Jackson (UK), Jean-Claude Correia (France) and Vincent Floderer (France; fig. 3) acknowledge the significant influence of traditional Japanese origami in their work but are actively creating a new, contemporary, European practice. In an e-mail to the Crafts Council, Paul Jackson lobbied: 'Paper folding is not all cranes and brontosauruses.' His intention was not to belie the charms of the popular images of origami; indeed, his enthusiasm for the medium comes from the 'anyone can have a go' nature of the material and techniques of folding.

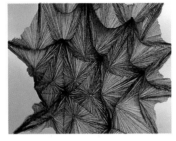

3
Vincent Floderer
*0/24*Δ*, 1999 (see p. 59)

Once the decision had been made to focus this survey on sculptural and constructional work, the trickier problem arose of how to handle the inclusion of wet-paper techniques and papermaking. In the UK the 1980s saw a myriad exhibitions reassessing paper as a material. *Paper Trails*, *Paper Work*, *Paper Round*, *The Paper Show* and *Paper as Image* all illustrated that paper could be used in its own right, as more than a support for other visual media. Handmade paper and papermaking attained a new status, attracting practitioners from disciplines ranging from textiles to sculpture.

Contemporary papermaking explores the physical nature of paper, experimenting with texture, the manipulation of surface and forming processes. For me as curator, this posed the question: 'When does texture and embossing become relief, and when does relief become sculpture?' Necessity dictated the need to narrow the field, which was clearly enormously wide-ranging. Therefore, I determined the criteria for selection to be a clear intention on the part of the artist/designer/maker to manipulate the material to create form. Form, whether functional, representational or purely aesthetic, had to be the main consideration, rather than surface or image.

Jane Thomas
Curator of *On Paper*
Exhibitions Officer at the Crafts Council Gallery

ON PAPER
JANE THOMAS

UNWRAPPING PAPER

The history of paper is a history of world trade, commerce and the migration of skills. Bureaucratic paperwork and the need to record political, legal, religious and economic information has been the driving force behind its development. As a support for data, it has been used as a means of management and control to maintain a social hierarchy. And yet it has become the most basic of materials, and, in tandem with printing, has put learning and knowledge within the common man's grasp.

Paper is a constructed material made from fibre, usually cellulose from plants and trees, but also rags and other fibrous materials such as silk, and is generally pressed into sheet form. Its invention in AD 105 is attributed to Ts'ai Lun, who was responsible for the Imperial Library in China. Ts'ai Lun experimented with linen, hemp and bamboo, finally choosing the bark of the mulberry tree. Paper served China's developing bureaucracy and became a means of economic management with the issue of paper money. In addition, it acquired a spiritual and cultural significance as the carrier of prayer and intellectual knowledge. Paper objects were burned at funerals, and paper representations of Buddhist and Taoist gods pasted on to the walls of homes to protect them from misfortune.

Paper's introduction to Japan by a Korean priest was in the form of sacred texts, and it was quickly taken up as a sacred material in Shinto ceremonies. Copies of these scripts were commissioned by the fashionable aristocracy, and so demand for paper increased. It became a symbol of purity, and paper objects are still used in Japan as talismans for good luck and to exorcise demons. For formal Shinto ceremonies the priest still wears *kamiko* (a paper robe) and a lacquered paper headdress.

4
Kashmiri papier-mâché bowl, 1910
London, Victoria and Albert Museum

5
Kashmiri papier-mâché pen box, 19th century
London, Victoria and Albert Museum

Paper represented wealth – financial, intellectual and spiritual. Around the centres of paper manufacture sprang up small businesses producing paper goods – lanterns, fans, screens and so on. However, the geography of Japan, an unsettled and often violent political situation, and poor transport initially kept paper an expensive luxury, with fine paper kimonos being valued as highly as silk. This was to change during the peace of the Edo era, when production took off. Now that

Kashmiri papier-mâché bowl, 1910 (detail; see fig. 4)

6
Tomoko Azumi
Folding stool, 1993
Cardboard and cherry veneer
35 × 15 × 56 cm
London, Crafts Council Collection

There has been a tradition of paper being used for furniture, usually laminated for strength. Eastern imports influenced Western European and American practice, enjoying their heyday from the mid-eighteenth century to the end of the nineteenth. Paper has maintained a presence within furniture design, with paper engineering and construction remaining a prominent module of product-design education. Tomoko Azumi created this folding stool from laminated corrugated cardboard.

paper could be mass-produced, the income generated in tax through the trade of paper and lacquer-ware was soon second only to that of rice.

In AD 751 Arabs conquered the city of Samarkand in central Asia, taking many Chinese prisoners, and with them their papermaking skills, to the Islamic world. Manufacturing bases developed in Baghdad, Damascus and Cairo, and it was from here that paper was introduced to Europe as an Arab import. The European paper industry started in Spain, with centres in Cordoba, Seville and Xativa. By 1275 it had reached Fabriano in Italy, which remains a renowned paper-manufacturing base. The first English mill was set up some two hundred years later in Hertfordshire, long after France, Germany and The Netherlands had established paper-manufacturing industries. With the invention of the Hollander beater, still an essential piece of studio equipment for fine papermaking, The Netherlands took up the mantle as the centre of European production in the seventeenth century.

In 1798 Frenchman Nicholas Louis Roberts patented a machine that could produce paper in indefinite lengths. This was developed by brothers Henry and Sealy Fourdrinier, who commissioned engineer Bryon Donkin to build the Fourdrinier machine. The first successful machine was installed at their paper mill in Hertfordshire in 1803, and full mechanization was in place by the end of the nineteenth century.

Paper had become the preferred support for writing and illustration, displacing parchment and vellum. The development of printing techniques and the subsequent increase in literacy encouraged paper production further. Low-cost materials and production quickly made paper an everyday, cheap and disposable commodity. It was no longer a luxury item for the privileged few. Although it remained the lubricant for the machines of commercial and social government, it also provided a way of distributing information and knowledge to the lower classes, proving itself a great social leveller.

The cheapness and availability of paper has also provided a material for the production of objects by tradesmen, artisans and artists. Traditional Japanese paper, *washi*, has a strength, translucency and flexibility that make it suitable for many applications – paper fans, umbrellas, bags, banners, masks, kites, lanterns, tarpaulins, clothing, screens and windows. In Korea paper was lacquered to produce furniture, and oiled paper was used for floor coverings and even boat sails. The Indian province of Kashmir built a reputation for highly decorated papier-mâché boxes, dressing tableware, bangles and vases (see figs. 4 and 5). Persia produced plates, mirror boxes and pencil cases. Missionaries, sailors and travellers took many of these products home with them as popular souvenirs.

After the example of these Eastern imports, and because of inexpensive manufacturing costs, the commercial viability of the use of paper for the production of objects was recognized worldwide. Lacquered papier mâché was adopted for the production of furniture and architectural decoration throughout Western Europe and America, enjoying its heyday from the mid-eighteenth century to the end of the nineteenth. Other papier-mâché and paper products included clock cases, sewing-machine boxes, chess sets and dolls' heads. In 1883 a Dresden watchmaker created a timepiece entirely of papier mâché and sheet paper.

In 1940s war-torn Finland, shortages of almost every commodity resulted in the creative use of paper to manufacture objects from clothing and shoes to rugs and curtains. However, the years following the war saw a rapid decline in the industry. This was turned around almost entirely by the cultural impact of American papermakers such as Douglass Morse Howell and the creation of the genre 'paper art'. Strongly influenced by American art and craft throughout the 1960s and 1970s, Finnish artists re-enlivened their flagging paper industry, and Finland remains one of the most famous of paper-producing countries.

Papermaking had been introduced to the American colonies in 1690. Mechanization created a healthy industry, but papermaking by hand had virtually died out by the early twentieth century. In the late 1920s paper historian Dard Hunter began to document the tradition of papermaking by hand in America and worldwide. By the late 1950s his books on the subject and his collection of artefacts had revitalized interest in the craft, and spurred on artists and craftspeople such as Howell to explore its possibilities.

Our relationship with paper remains strong, not just because it is useful, but because it has qualities that please us. We take pleasure in the ownership of books as objects, not just in their contents; we have a seemingly endless appetite for special packaging and stationery, supporting through our consumption an enormous manufacturing industry and retailers such as Paperchase. At a time when the computer is perceived as the replacement for the handwritten word, and digital media rule, paper's predicted redundancy has not diminished its attractiveness as a material in its own right. 'Paper art' explores this relationship with material, playing a major rôle in the continuing profile of paper and its use, interpretation and development in contemporary cultural practice.

NEW PAPER ART

Although in many countries, such as Japan and China, paper has always held a particular significance in spiritual and cultural activity, the status of paper within Western art has historically been peripheral to that of other media. It is a support; a material on to which artists can sketch, paint or write; a surface on which to apply other material.

Paper has always been used in folk art, however, in both Western and Eastern cultures, and this work has in turn had a formative influence on twentieth-century 'modern' art. Nevertheless, papier mâché and origami have in the past been accredited with little more importance than that of interesting curiosities, and handmade paper has been seen as the product of a cottage industry. Painting and sculpture were privileged, and were defined by solid durable materials with longevity, such as canvas, marble and bronze. Artists were making works for our future heritage, to be seen in museums.

There has been a significant shift in this viewpoint in the areas of design and craft. Papermaking, paper folding, paper engineering and paper sculpture are being employed in product design, architecture, graphic and publishing applications, jewellery, and the production of crafted functional and sculptural objects. It is represented in contemporary fine-art sculpture through the work of such artists as Brian Griffiths and Susan Stockwell. There is still, however, an inclination on the part of art dealers, galleries and museums to view the material as impermanent and of lesser value. The absurdity of this is made clear, since works on paper continue to be collected despite the very same conservational issues.

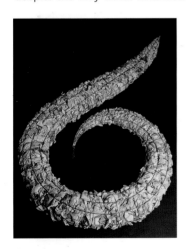 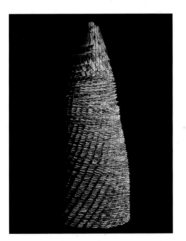 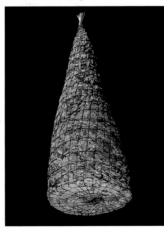

7
Julia Manheim
Rough Stuff, 1990
Wire and newspaper
length 238 cm

8
Julia Manheim
Standing Idol, 1991
Wire and newspaper
height 259 cm

9
Julia Manheim
Fallen Idol, 1991
Wire and newspaper
length 259 cm

Over the past fifty years an ever-growing number of practitioners from disciplines such as textiles, ceramics, sculpture, painting and design have used paper as their main material. There is a strong support structure for this work through regular international seminars, biennales and specialist galleries. The medium, which still suffers from the preconceived value systems established in the nineteenth century and earlier part of the twentieth, has come a long way

Andrea Stanley, *Turned Paper Form*, 2001 (detail; see p. 38)

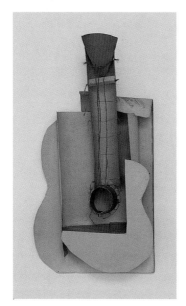

10

Pablo Picasso

Maquette for Guitar, 1912

Card, paper, string and wire

65.1 × 33 × 19 cm

New York, The Museum of Modern Art

Pablo Picasso and Georges Braque championed collage, employing common materials in unorthodox ways and constructing works from found objects, cardboard and wallpaper. In 1912 Braque wrote, 'I am profiting from my stay in the country by doing things one cannot do in Paris; among other things, paper sculpture has given me great satisfaction.' This relief and constructed work opened new avenues of creativity for Picasso, but for Braque, who had a fundamental preference for the two-dimensional image, this was an important experimental time in the development of *papier collé*.

towards shedding its artisan identity and establishing its place within the visual arts. The acceptance of collage as a distinct medium was probably the first recognition of paper as a material in its own right by the Western art establishment. Its inception into the arena of twentieth-century fine art marked a radical departure from the heroic epic, the grand or grandiose. Instead, work often served as a simple document of society through fragments of intimate and peripheral everyday lives – newspapers, travel tickets, pages from books, photographs and found images. The valueless was being revalued. Successive generations of artists, through Cubism, Futurism and the Dadaists to the present day, have employed collage and the found object as a medium capable of reflecting the political and social values of the time. Artists such as Pablo Picasso and Georges Braque explored the nature of paper, taking it from flat collage into three dimensions (see fig. 10). This work was more related to painting than sculpture, and, in the main, did not develop beyond wall-based reliefs.

The appropriation of found images and text remains a constant strand in the development of the media, being employed by such contemporary artists, designers and craftspeople as Andrea Stanley (pp. 37–38). The surfaces of Stanley's turned forms are reminiscent of both Futurist collage and of twelfth-century Japanese text collages. The fragments of text are random, falling in map-like contours over the form. Great care and consideration is taken in the placement of the final layers of the papier-mâché shell, which is then turned on a lath. The finished surface, patinated with text, resembles Japanese lacquer-work, but on closer inspection reveals whole words and phrases.

Newsprint is utilized in a more immediate way in Julia Manheim's work of the early 1990s (see figs. 7–9). *Ecu Ecu* and *Guardian Angel* are large, wire-constructed forms filled with loosely balled and crumpled newspaper. In the largest of this series, *Tall Stories*, the metal binding appears to strain under the wads of horizontally stacked newspapers.

Australian paper and ceramic artist Graham Hay also uses found documents and papers (fig. 11; p. 36). These are constructed into blocks, sanded and carved to create sculptural form. Hay first began to use paper as paper clay within his ceramics studio, asserting, 'Using papermaking techniques within the ceramic studio to make paper clay sensitizes the artist to paper, paper imagery and the role of paper in society.' Increasingly, he has found himself considering the sources of paper – the daily tide of newspapers, magazines, bureaucracy, phone books, leaflets and so on. Despite the promise of a digital future, our society remains a mass consumer of paper, as we surround ourselves with libraries of material and create in our domestic and work environments what Hay describes as 'paper nests'. As an artist, much of the paper he

accumulates is sent to him from galleries and arts bodies – correspondence regarding the administration of exhibitions, invitations, catalogues, price lists and so on. The use of this material offers an apt opportunity to comment on the activity of his professional practice. He began to work directly with it, drilling, compressing, cutting, sanding and binding. The documents and the information on them are carefully selected, as is the shape they are worked into, whether they can be read in their final form or not.

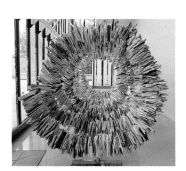

11
Graham Hay
*Curved Information as Object:
Four Tons of Official Documents*,
1998
Government documents
250 × 250 × 600 cm

In this commission for the foyer of the High Court in Canberra, Australia, Hay works four tons of old annual reports, draft policy documents, senate papers and inter-department reports (including a report on how to write reports) into a spiralling vortex.

In addition to the acceptance of collage, particularly into fine-art practice, the explorations of American papermaker Douglass Morse Howell into the nature and structure of paper also introduced many artists and craftspeople to the material. He is widely credited with the development of paper as an artistic medium. Together with the writings of paper historian Dard Hunter, Howell's example created a lively critical debate and encouraged a burgeoning new movement in America. The first papermaking course within an art school was established at the Cranbrook Academy of Art, Michigan. It was here that Laurence Barker taught throughout the 1960s. Barker went on to set up the Barcelona Paper Workshop, which is where Jacki Parry refined her skills before setting up the Glasgow-based Paper Workshop. Through the work of projects such as these, where makers could learn and share skills and facilities, papermaking by hand was coming of age.

Further to this, experimentation with fibre and nonwoven materials – including paper – by the textile artists in the International Fibre Art Movement offered a new context in which to exhibit works in paper. Collaborations between papermakers and fine artists, such as Ken Tyler's with Robert Rauschenberg, Anthony Caro and David Hockney while working at Gemini GEL, a commercial workshop in Los Angeles, have also done much for the recognition of paper, placing it firmly in the wider critical debate about art and craft. In an essay for the exhibition catalogue *Paper as Image* (1983), Silvie Turner states, 'Not only has there been an enlivenment of the craft of papermaking, but the experience of paper and the changing ideas of its nature appear to have refreshed artists at a crucial and evolving point in its history.' Paper was no longer just a product for use, it could hold its own as an object. Released from its functional use as a carrier of images or text, its own materiality could be explored, and the need to form exclusively two-dimensional sheets dispensed with. The matter of its make-up, the paper pulp, could be manipulated, modelled or cast. This was, of course, nothing new, as there are established traditions of papier-mâché sculpture in both Western and Eastern folk art. The approach to the material and the arena in which this work was now being shown and judged, however, were new.

The First International Biennale of Handmade Paper was in West Germany in 1986. In the same year the International Association of Hand Papermakers and Paper Artists (IAPMA) was formed, an indication of the level of international co-operation that was growing throughout the 1980s. In

1990 the Paper Art Gallery opened in Kuusankoski, the centre of Finnish paper manufacturing. The Centre for Finnish Paper Art opened in Porvoo in 1993, and was followed by Finland's first International Paper Biennale in 1995. Finland, The Netherlands, Germany and Switzerland continue to lead in the promotion of paper art.

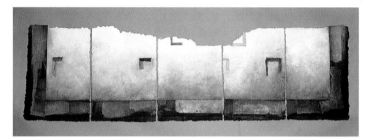

12
Carol Farrow
Beneath the Surface Again,
2000
Handmade and cast paper
26.2 × 7.6 cm

In the UK, makers such as Carol Farrow (fig. 12) and Jacki Parry (fig. 13; pp. 34–35) were primary participants in shaping this new movement. Papermaking was still a 'kitchen sink' cottage industry, based around food processors and sieves. Farrow and Parry quickly saw the need to provide artists and makers with the training and facilities to approach papermaking in a more professional manner. Carol Farrow was awarded a Paper Works Fellowship from Oxford Polytechnic in 1986, and ran papermaking courses throughout the 1980s. Sophie Dawson replaced Farrow at Oxford, teaching papermaking as a key module within the polytechnic's foundation course in art and design for a further ten years. Jacki Parry introduced papermaking into the curriculum at Glasgow School of Art, and founded the Paper Workshop, which offers specialist instruction and access to a well-equipped space for artists to work independently. There are still few art colleges that provide training in papermaking, and generally this is as a module of other courses, such as printmaking at Glasgow or bookbinding at Oxford.

13
Jacki Parry
Ways of Editing, 1998
Handmade and cast paper
16 × 20 cm

In a recent conversation with Jacki Parry I asked if she felt that the lack of representation of paper as a medium in our colleges was indicative of the continuing battle to recognize paper as a valid medium within the visual arts. She, however, felt that this was better expained by the tendency in current arts practice to move away from material-specific work: artists no longer want to be associated with one medium in particular, but want to be seen as creative creatures who can dip their toes into any area. Current trends in critical review and the presentation of art generate a fear of being associated with a specialized area, such as papermaking, and of being marginalized as a maker of 'craft'. I will leave the debate over the difference between craft and art to the theorists, but it is saddening that the assumption lingers that having a relationship with a particular material or technique does not allow the same exploration of concepts or aesthetic issues as is available to the fine artist – that skill negates intellect. Jacki Parry's contribution to paper-art education has been significant, both through her teaching at the Glasgow School of Art, and the founding of the Paper Workshop in 1986. Training in papermaking in the UK, however, relies on the generosity of makers in sharing their skills and facilities with new practitioners and students outside the domain of the art school, or on artists themselves finding their own way by trial and error.

Parry's approach to her own work has always been sculptural. The objects she creates are organic, inspired by both the natural world and the shapes of the objects and tools she uses in the process of making – hammers, beaters and so on. There is, however, another layer of meaning to the work, which again shows a concern with the concept of paper as a support for text, and with language, messages and codes. The series Ways of Editing demonstrates a vocabulary that uses form, in which the material of the form has a heightened significance. The works are cast over specially made sandbags, resulting in taut membranes, and, despite their small scale, the objects have a tension and power that command attention. An earlier work, *Visible Traces*, was made in response to the artist's being allowed access to the government papers concerning the disappearance of her brother during a fishing trip in Australia. Jacki Parry's work constitutes a fusion of form and content. A lifetime of studying paper has allowed her to concentrate her thoughts and refine her means of expression.

At the same time as Dard Hunter was writing about and collecting papermaking and works in paper in America, there was also a growing awareness of the Japanese tradition of origami. The International Origami Society was established in 1954 to promote the medium to an international audience. The following year saw a major exhibition of works by Akira Yoshizawa in The Netherlands. Now in his eighties, Akira Yoshizawa is the world's most respected origami artist (figs. 14 and 15; pp. 54–56). This exhibition brought him, and the practice of origami, to the attention of the Western art world. Still working and exhibiting internationally, Yoshizawa's work continues to contribute to the ongoing dialogue and cross-fertilization between Japanese and Western artists, craftspeople and designers. Called *sensei* (master), he is possibly the most prolific folder in the history of origami.

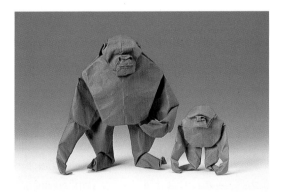
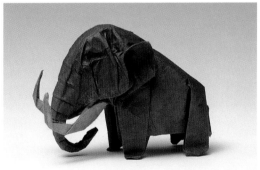

14
Akira Yoshizawa
Gorillas, 2000
Origami
22 × 22 × 8 cm and 10 × 10 × 4 cm

15
Akira Yoshizawa
Mammoth, 2000
Origami
5.5 × 11.5 × 6 cm

In the West, both paper folding and papermaking have evolved alongside an existing legacy of traditional Japanese practice. Both the spiritual and functional uses of *washi* influenced and continues to influence the development of contemporary papermaking and paper folding internationally. Western culture has taken the techniques, symbolism and practical application of paper and made its own visual language. Contemporary practitioners such as Paul Jackson (pp. 62–63), Jean-Claude Correia (pp. 60–61) and Vincent Floderer (pp. 58–59) are informed by

the Japanese tradition, but also by craft and art history, the natural world and the mathematics of nature. The twin obsessions of complexity and literal representation in origami have given way to purer aesthetic concerns. Paper-folding artists are demonstrating a dexterity in manipulating their chosen material to create unique objects and sculptural works that communicate visually, in preference to clever invention. For many paper folders, the emphasis has shifted from the skill of construction to the finished object itself. Japanese makers such as Akira Yoshizawa, Masahiro Chatani and, more recently, Tomoko Fuse (p. 64) continue to be a major influence, but paper folding has become an international art genre.

Paul Jackson's work ranges from organic abstract objects to design commissions for print. Recent explorations have led to a series of works that uses only a single crease to create sculptural form. They are of a purely temporary nature, without the strength of multiple folding. There is a strong sculptural element, using the curve and tensile strength of the paper – apparently the simplest of interactions, but attaining a minimalist sophistication. Jackson says of his work, 'I came to regard these objects not as origami, but as folded paper sculptures. This differentiation may seem pedantic, but it separates my work from the model-making craft traditions of origami and places it within the critical traditions of Western fine-art sculpture.'

In contrast to this approach, 'clever invention' continues to be embraced by paper engineers working in illustration, packaging, product and graphic design, and paper folders interested in mathematical and modular models. Origamic Architecture and paper engineering have developed from the same traditions of origami. Much of the work is experimental, producing sculptural objects that explore the possibilities of construction in sheet paper. Masahiro Chatani established the term 'Origamic Architecture', and through his work and publications has influenced the study of paper engineering and its applications in design.

16
Kei Ito
Paper Cloak, 1998
Paper (Tyvek)
150 × 90 cm

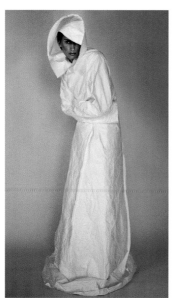

Although the work of such artists as Damian Cruikshank (pp. 66–67) has aesthetic concerns, their interest in paper appears to be based more in testing possibilities. Cruikshank works towards generating models that have a sense of internal logic. He explores spatial concerns through the relationships between lines and points. His practice centres on the manipulation of one form, a single sheet of paper, to develop an altogether more sophisticated new form. The intermediate stages represent a kind of growth, each new model fuelling future research and informing the approach for the next.

While Tomoko Fuse, Masahiro Chatani and Damian Cruikshank explore the capabilities of folding in their models, paper is being put to an altogether more functional use by designers and craftspeople. Victorian valentines, paper theatres and children's

pop-up books chart a history of manipulating paper, and, along with origami, form the foundation of our perception of paper folding. Paper has been and continues to be explored as a material for popular consumption, and is employed for many purposes, both commercial and domestic. A zone in London's Millennium Dome was designed and constructed in paper logs by the architects Philip Gumuchdjian and Steven Spence. Gumuchdjian brought in Shigeru Ban, who had been constructing buildings in paper since 1986, as consultant on the project. This was not a new use for paper: it had already been used as long ago as the eighteenth century to create prefabricated housing, and even a church in Finland. At the Bauhaus in 1926 Josef Albers set a course project looking at paper – reinforced by folds, cutting, and fastening systems – as a material for new forms of construction; some results were adopted for architecture, product and furniture design. The folding of sheet material remains an important module of product-design courses, and a recent exhibition, *Papier Mobel*, at the Galerie Handwerk in Munich showcased a series of chairs engineered in paper by design students.

Clothing, too, has been produced in paper, with a tradition in Japan that dates from the eleventh century. Paper sheets were cut and stitched, often treated with linseed or sesame oil to waterproof them. Yarn was also spun from strips of paper to produce a woven fabric. The finest paper kimonos were valued as highly as silk, while farm workers and fishermen wore fabrics recycled from waste paper, often government and bureaucratic documents. Very few craftspeople with these traditional skills remain in Japan, and yet, internationally, contemporary textile and fashion designers are reassessing paper and exploring its possibilities. Issey Miyake, Kei Ito (fig. 16; pp. 104–05) and

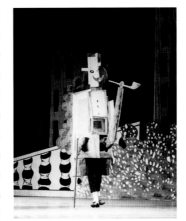

17
Pablo Picasso
The French Manager, costume for the ballet *Parade*, presented by the Théâtre du Chatelet, Paris, 1917
Card and fabric

Pablo Picasso created costumes for the ballet *Parade*, presented at the Théâtre du Chatelet in 1917. His characters the French and American Managers resembled walking versions of his sculptural experiments in card rather than costumes, and together with his set design gave a surreal flavour to Diaghilev's production, with a scenario by Jean Cocteau and music by Erik Satie. It was in the programme for the first performance of Parade that the term 'su-realisme' was coined by Guillaume Apollinaire.

Hussein Chalayan have all produced clothing in paper, and this trend is now moving from the catwalk to the high street. Creased paper shirts by John Rocha, paper Aertex tops by Krizia World, and paper-look jackets and banana-fibre hats by Paul Smith are all available to buy. For TS Design, Chalayan has created a range of clothing that includes a paper shift dress and Velcro-fastening trousers, with matching paper purse bag. The development of Tyvek by DuPont has provided a paper that can be worn again and again, and can even be machine-washed. This, and a developing interest in nonwoven fabrics, marks a future path for paper within the fashion and textile industries. The notion of paper clothing, however, is still a novelty in Western culture and presents the interesting concept of disposability to our consumer-based society. This was explored in the 1960s by Pop Artist James Rosenquit, who wore a paper suit to many fashionable events and functions. He was commissioned by Hugo Boss to redesign the suit for the 1990s, and an example is now on permanent display in the Metropolitan Museum of Art in New York.

Clothing as art, whether wearable or not, opens up the possibilities of exploring the material of its manufacture without the constraints of durability and comfort. At the end of the 1990s, Royal College of Art graduate Charlie Thomas (pp. 70–73) was turning business envelopes inside out,

using the printed security pattern as a fabric with which to create business shirts. These were bought and displayed by the Terence Conran-owned restaurant Sartoria. Other paper garments followed, exhibited during London Fashion Week 1999 and forming part of a Sotheby's show of unwearable clothes, *Out of the Closet*. Working closely with the fashion industry, Thomas intended his pieces to be associated with, but not actually to be, 'fashion' garments or accessories. Although these tailored suits are created to be photographed on a figure, the wearer is almost worn by, rather that wears, the clothing. The result is a slick, stylish, graphic image that takes the flat paper sheets on a journey through the three-dimensional construction of the model and back to a two-dimensional image intended for the pages of a glossy magazine: another paper object.

Carol Andrews's interest in clothing is much more concerned with the history of dress than fashion. She makes organic sculptures from paper and other two-dimensional materials, taking techniques from such crafts as embroidery, basketry and origami to build unusual forms with complex surfaces. The embroidery technique of smocking was employed to create *Paper Wrap* (p. 66). This work draws on traditional skills and historical costume. Although it is not intended to represent dress, its form and construction makes a visually recognizable reference to clothing.

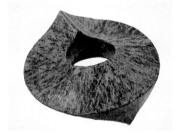

18
Julia Manheim
Flared Cone Necklace, 1986
Papier mâché
8 × 18 × 26 cm

Another example of the adoption of paper within fashion is paper jewellery and accessories. Julia Manheim, Angela O'Kelly (pp. 98–99) and Julia Keyte (p. 79) have been joined by a new crop of jewellery graduates, such as Alison Wilson-Hart (pp. 74–75) and Sue Lane (pp. 102–03). And, as it becomes widely acceptable to experiment with non-precious materials, paper is becoming more commonly used as one or the main material in the construction of jewellery. Julia Manheim's papier-mâché jewellery and sculpture of the 1980s provided a leading influence (fig. 18). Twenty-five years of challenging professional practice have proven her position as a leading experimental maker in the UK. During the 1990s she moved away from jewellery to make sculpture, and her recent work uses material other than paper. Her earlier body of work in paper, and its documentation in both jewellery and paper-art publications, has provided a legacy that continues to inform contemporary practice.

Julia Keyte has used paper as an experimental material to aid the design process of her work, which would then be made in more permanent and conventionally used material. Although this experimental work constitutes a large proportion of her portfolio, it is only recently that she has had the opportunity to refine, develop and ultimately exhibit this body of work. Enjoying its immediate nature, she uses a variety of basic papers, such as cartridge, lined and tracing paper. She incorporates roll-printing processes, bleaching and intricate cutting and layering to create subtle and delicate patterning. The project Hightec-Lowtec, which was funded by the Arts Council of England, gave Julia Keyte the opportunity of a twenty-day placement in the industrial sector. BFF Nonwovens, a company that produces high-volume nonwoven fabrics for such applications as baby wipes, medical dressings, kitchen cloths and filters, presented further scope for

experimenting with non-precious, paper-like materials. This experience is now being utilized in her new series of work.

Recent graduate Sue Lane has chosen paper as her main material for its translucency. She says of her work, 'Through material manipulation I have tried to create translucent, delicate forms that signify purity and preciousness.' In the same way that Japanese Shinto religious artefacts bestow a symbolism of purity on to the white paper of their construction, these contemporary amulets suggest that there may be an inherent meaning in their form and materiality. It is the object itself, its scale and weight, its placement within an environment and its tactile qualities, that concerns Sue Lane, rather than its wearability. The pieces are probably best described as jewellery; but jewellery worn against a wall, on a table or within the pages of a book. When the pieces are worn it is with the clothing as a backdrop rather than the work as decoration to the clothes. There is an intimacy of scale, which relates to jewellery, but there is also a sense of the objects being apart from the body – they are totems, artefacts and fetishes.

As in the case of the other artists, craftspeople and designers discussed, these jewellers are engaging with the material for its aesthetic and tactile qualities. There is, of course, an added dimension of playfulness when non-precious material is used in a discipline that is usually associated with preciousness and value.

The sculptural application of paper owes a great debt to folk art and religious icons and talismans. From its first conception paper has been used in Shinto, Buddhist and Taoist ceremonies and annual celebrations. Objects continue to be produced as gifts for the gods and protective charms. Japanese papier-mâché effigies are used for exorcism and good luck. These are usually Buddhist figures and popular folk or religious heroes, doubling as toys and

19
Inu Harikun (Dog God)
Traditional Japanese *engi-e*
(papier-mâché folk toy)

decorations. One of the most common figures to be portrayed is the dog. This is offered to a newborn male child when he is presented to the shrine for the first time. This remains a very popular image, even now.

Mexico also has a tradition of papier-mâché objects for religious and/or celebratory purposes. Figures known as Judases are made to commemorate All Souls Day and the Day of the Dead, when brightly coloured skeletons and skulls decorate homes. Papier-mâché masks are worn by priests to represent the deities they are honouring, and natives wear the masks of their ancestors to utilize their strength and exert a magical power. The *piñatas* is a popular feature of carnival and Christmas celebrations. A papier-mâché star, ship, fish or flower, containing a clay pot full of sweets, is beaten by children until its contents fall to the ground to be consumed.

In Europe papier-mâché figures are used for celebrations, carnivals and entertainment. Spain and Italy particularly have a strong tradition of making puppets and masks, the most enduring figure

20
Mhairi Corr
Olympia Cairns, 2000
Papier mâché
80 × 45 × 36 cm

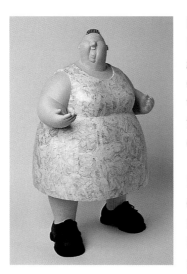

being Punchinello. Throughout Europe giant heads and figures have also been paraded in processions. The origins of these giants (*cabezudos*) are medieval. There has been a renaissance of this form of celebratory art, as public funding has favoured visible community projects. Paper lanterns and sculptural fantasy figures made of paper over frames of willow populate our contemporary carnivals.

Drawing on the traditions of this work and the skills that have evolved in its production, a genre of representational papier-mâché figures has become established. Practitioners such as Peter Rush, Linda Ayres and Mhairi Corr sculpt in paper and paper pulp to create figures as art for the gallery rather than the fiesta. Figures have always dominated the subject-matter of these artists. Often from fine-art or illustrative backgrounds, their aim is to comment on the human condition, either through humorous caricature or closely observed representation. In 1975 Linda Ayres showed a series of figures that portrayed the frail mortality of people. Papier mâché proved an ideal medium in which to represent old age, and a convenient extension to the observational drawings she had been making.

Figurative pieces in paper will always seem strange or surreal, as we are never able completely to suspend our perception of the material as something outside of art. Jon Atkinson (pp. 94–95) is a self-taught artist who for the past fifteen years has worked consistently to refine his skills in manipulating paper. Inspired by the works of Peter Rush, he has made his task the creation of 'anything' in paper, using techniques as diverse as papier mâché and the spinning of tissue paper. The choice of object is ordinary, mundane. The process of the object's representation is skilled, labour-intensive, with an obsessive attention to detail. The resulting work is a realistic 'copy'. It is an object, but not the object you are first led to believe it is. It is a jolt to the senses to realize that the rusty kettle, the leather jacket, the clod of earth are in fact made of paper. Our perception of reality is engaged in a playful game.

The work, however, refuses to be dismissed as clever representational curiosities. Photorealism in painting is something tangible and expected. When the representation of the object is three-dimensional and enters real space, 'our' space, the result is disquieting. The subject-matter is that of the found object, drawn from our real lives and projected into the realm of art. The representation of an object rather than its actual use separates us from the alternative reality that has been created. We become voyeurs, filling in the gaps of the narrative that is inherent in the objects, reading them as a code or language.

Finally, I come to the most familiar of paper objects, the book. The scrolling, folding or binding of paper to make a book must be the earliest form of paper construction. Like paper itself, it is a product with a purpose, but, also as in the case of paper, we have come to appreciate the visual

nature of the object. As the medium for our intellectual and cultural endeavours, books have always been placed by their content at the centre of artistic activity. As such, they have become symbolic, and visual artists are now exploring the object as a form. At their most extreme, artists' books and book forms can be purely sculptural and have no reliance on content. It is the suggestion or possibility of content that retains the identity of the work as a book.

Deb Rindl draws on paper folding to create books that can open out as sculptural forms or be folded down to be read (pp. 42–43). Although she enjoys the use of letterpress text, she is concerned with how this falls over the form of the book, rather than with readability. It is almost a surface decoration and, on occasions, dispensed with altogether. Meanwhile, Les Bicknell's work (pp. 48–49) has developed into large-scale installations that make only subtle references to their origins as book forms.

Jennie Farmer uses the form of the book in a different way, deconstructing and manipulating found books, dictionaries and thesauri, folding their pages and bindings to create new forms (p. 39). Still identifiably books, these works comment on the nature of paper as a medium for education and written culture. As in the work of Andrea Stanley and Graham Hay, the source and purpose of the text is important, but the need to be able to read it in the finished form is not.

Another artist whose work dissects the book form to create something new is Carl Jaycock (pp. 40–41). His specific focus on paper has been in its relationship to book pages. The deconstruction of textbooks, the foundation of educational and cultural ideas, allows the juxtaposition of pages to create a non-linear way of seeing the information. This allows the images and text to be seen in a way that was not possible in the original book form. Jaycock's work brings together the concepts of paper as knowledge, as collage and as found object, the manipulation of surface through simple cutting and folding, and new digital technologies. His multilayered constructions combine history with digital imaging. He draws on historical and cultural events for content, further fragmenting layers of computer-manipulated images. He says that his aim is to 'challenge conventional perceptions of cultural identity'. The resulting work has a very strong graphic feel, and, through the use of fairly simple techniques, has a complex relief surface with a fine sense of symmetry and order.

Looking at the work in this survey I have become aware of certain threads in the narrative of the use of paper in art: there is the nature of paper in its use as a carrier of information and language, prompting the development of personal codes and vocabularies; its choice as a material is an engagement with issues of language as it is employed as a vehicle for communication. Then there is the physical nature of paper itself, and the exploration of its structure, its tensile strength and flexibility. As paper itself has been elevated to a medium of artistic expression, so has the manipulation of paper, whether handmade, manufactured or found.

ABOUT PAPER
PAUL JACKSON

Why am I, and so many others, engaged with the manipulation of paper? It is easy for me to enthuse about the subject, as the re-forming of a sheet of paper from a flat to a three-dimensional form simply by cutting, folding and gluing is a transformation so dramatic as to sometimes appear closer to magic than to art. With volumetric sculptural materials such as clay or wood, the transformation is less dramatic, and with other sheet materials that will not hold a crease, such as fabric, the options for manipulation are limited. Paper, then, is a sometimes magical material.

Or perhaps 'alchemy' is a better word than 'magic'. The workaday nature of paper makes its transformation into forms of ingenuity and beauty all the more extraordinary. Something wonderful is unexpectedly conjured from something very mundane. The effect is heightened by the inherent passivity of a sheet of paper. It is given life and character only when manipulated.

This alchemy places the manipulative paper arts in a unique position. On the one hand, the objects made are art or craft objects, open to the same critical review as any other medium. On the other, they can sometimes appear to be outside the contexts of art and craft, closer to creative geometry, puzzle-solving or model-making. Indeed, many paper manipulators reject a description of their work as 'art'. This has proven a problem of context that has previously caused curators some hesitation in accepting paper manipulation as a technique worthy of a major themed exhibition.

Furthermore, the exploration of the possibilities of paper manipulation beyond folk art is relatively new and the practitioners widely scattered. The diversity of art, craft, design and educational contexts in which their work is shown does not provide an easy route to an overall picture of the current state of the practice. It is for this reason that *On Paper*, the first major exhibition to bring together some of the best current work, is so welcome.

For twenty years, I have been privileged to meet paper manipulators in many countries, travelling to teach, to exhibit or simply to visit as a friend. The word 'origami' is not always accorded much respect (in Japanese, *ori* means 'to fold' and *gami* means 'paper'). However, since the 1950s, there has been an extraordinary explosion of interest around the world in this most basic of making activities. Basic? Yes. In its purest form the paper is only folded, not cut, glued or decorated. No other making activity requires just a pair of hands and no tools. It is a craft that can be practised by anybody, anywhere, at any time, at an absolutely minimum cost.

The simplicity of the activity has attracted many practitioners and encouraged the establishment of origami societies in approximately thirty-five countries, some with several thousand members. Many of these societies hold regular national and international conventions and conferences. The largest is in New York, where the annual Origami USA convention attracts some 650 people for a series of weekend classes, workshops and discussions. Additionally, many societies publish regular magazines, collections of newly created models and booklets on specialized topics. These topics range from esoteric discussions on so-called 'scenic routes' (the most beautiful folding sequence

Cas Holmes, *Slate-Book-Leaf*, 2001 (detail; see pp. 46–47)

to achieve a model, rarely the most direct route – an approach that defines origami as a 'folding' art, not a 'folded' art), to monographs on the work of different creators and origami games.

The number of documented designs is unknown, but must amount to several tens of thousands, ranging in style from the audaciously simple to the fearsomely complex. There is no such concept as 'the' origami dog, cat, steam train or whatever. For example, an exhibition was held in Paris in the early 1990s of eighty-eight different origami elephants collected worldwide from different creators by French paper folder Alain Georgeot. Similarly, in 'The Elephantine Challenge', a column that ran from 1992 to 1995 in *British Origami*, the magazine of the British Origami Society, origami creators were challenged to design an elephant in seven folds or less. The challenge elicited many responses using gradually fewer and fewer folds, and was eventually abandoned when a recognizable one-fold elephant was created.

At the Fourth Southeast Origami Festival in Charlotte, North Carolina, held during September 2000, some ten thousand children were taught origami in schools by visiting origami experts as part of an educational programme. During the focal weekend of the festival, an estimated ten thousand local people attended free folding classes held in marquees ranged along a block of the closed-off main street in the city centre. The largest model on display at the festival was a skeleton of a life-size brachiosaurus, twenty-three metres by seven metres, folded from twenty-three three-metre squares of paper. And in the spring of 2001 in the exclusive Ginza district of Tokyo, a major exhibition of two thousand pieces by the great Japanese origami *sensei* Akira Yoshizawa – to mark his eighty-eighth birthday – drew an unprecedented number of visitors, before transferring to other cities to similar popular acclaim.

The positive use of origami as an educational and therapeutic tool is now well understood, with several conferences having been held since 1991 in the UK and USA. In education, it is widely acknowledged to be a valuable tool, teaching children motor skills, an understanding of space and orientation, logical thinking, how to follow sequential instructions, concentration, geometry and an appreciation of precision. In Russia, the St Petersburg Origami Centre is in regular contact with many hundreds of teachers throughout the country, who regularly teach origami, now recognized by the Ministry of Education as an official curriculum subject.

In Israel, the Israeli Origami Center employs twenty-five teachers trained by the centre to teach origami regularly in fifty schools to approximately 12,500 children. Well taught, origami is not only educational, but also huge fun for children, most of whom absolutely adore it. The renowned stage illusionist Robert Harbin, credited with introducing origami to the UK in the 1950s, said that children were guaranteed to like only two things: chocolate and origami.

Therapeutically, origami enables children, and adults, to improve their self-esteem dramatically: the sense of achievement when a model has been completed is intense, and, with application, anyone can fold well. Origami is also an excellent therapy for people with damaged hands.

In recent decades the traditional Japanese origami 'crane' model has become associated with the Peace Movement, because the folding of one thousand cranes is said to bring about peace. With this legend in mind, the Israeli Origami Center has officially presented garlands of one thousand cranes to the late King Hussein of Jordan (an important figure in the Middle Eastern peace process), Pope John Paul II and the Dalai Lama. Each year, millions of cranes are sent to the Peace Park in Hiroshima, Japan, and displayed to spectacular effect. Indeed, such is the popularity of origami that a good case could be made for it being one of the world's most widely practised crafts. The reasons for this wide appeal are not difficult to find. It is essentially simple but also endlessly complex. The designs can be beautiful, but there is a strong element of problem-solving 'cleverness' that appeals to those people for whom notions of 'beauty' and 'art' are problematic, notably children. It is inexpensive, clean, small-scale, portable, repeatable. It is creatively playful, yet necessarily logical, and a good result can be achieved even by a beginner.

With the growth of interest in creative origami, the possibilities of the traditional 'bases' from which many models are created have been almost exhausted. In recent years, little work made from these bases has offered anything very new. Because of this, the creative emphasis has shifted to those creators who use more idiosyncratic techniques. For example, in the last decade or so, a number of so-called 'origami artists' have emerged whose work is not only technically sophisticated but also visually beautiful. They are inspired more by the occurrence of 'the fold' in the natural world than by the traditional challenge of making an illustrative likeness of an animal, object or mathematical form.

A number of creators whose work is extraordinarily complex and detailed are developing their designs aided by computer programmes that plot the distribution of free points. For example, the distribution of points for a set of reindeer antlers can be efficiently mapped (technically, creative origami is simply about the creation of correctly distributed free points) on a sheet of paper. The artistic skills of the creator are then used to make the design visually beautiful, much as a pianist interprets a score to create music from the notes. Other creators use an advanced knowledge of mathematics and geometry to design elaborate three-dimensional mathematical forms. Shallow reliefs made from repeat crease patterns have been derived from the interlocking tile patterns created by the Moors at the Alhambra Palace in Spain. Another group of creators uses manipulative techniques that are difficult for others to copy with finesse, such as using curved creases, crumpling, or folding the paper when wet, so that the paper is moulded into shape with a series of softly made creases that stay in position when the paper is dry.

There is a surprising amount of interest in origami among scientists. In biology, the analysis and classification of the structure of leaves and how they unfurl is made easier when schematized by an origami crease pattern. In engineering, the stress patterns and consequent buckling in cylindrical pipes when pressure is applied from the ends can be expressed as an origami crease pattern, and wire rods embedded into the pipe along the lines of the creases to create extra strength. An origami map fold (the *miura-ori* map fold) opens a large map from a small area in

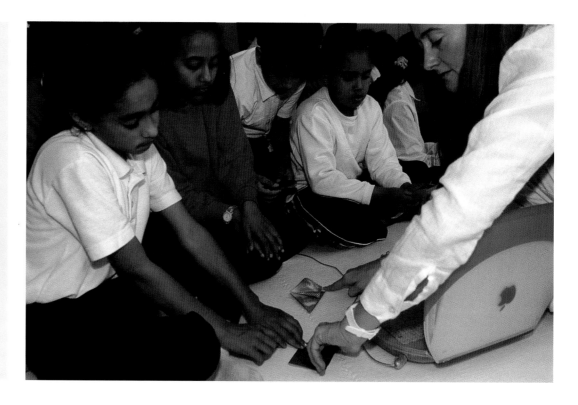

just one fluid movement. The design is so simple and reliable that it was used in the solar panelling on a Japanese satellite.

The clearest link is between origami and mathematics or geometry. A crease pattern is an inherently mathematical/geometric structure that can be analysed in two dimensions or three dimensions to an extraordinary level of complexity. At a simple level, the analysis can be used in schools to teach a 'hands on' approach to the principles of mathematics and geometry, including elegant methods of constructing fractions, divisions, areas, angles and polygons, and of proving numerous geometric theorems. At an advanced level, origami has contributed a great deal to our understanding of topology, the study of surfaces. An advanced knowledge of mathematics can also enable origami forms of great beauty and sophistication to be created.

There is also much interest among designers. Very few designers would regard themselves as origami experts, but many apply folding techniques to their work, not necessarily in paper. Perhaps the most celebrated example is that of the Japanese fashion designer Issey Miyake, who has often described his folded- or crumpled-fabric garments as 'origami'. A general survey of quality contemporary design in other design areas, such as textiles, jewellery, ceramics, product design, furniture, packaging, architecture and interior design, will reveal a surprising amount of sophisticated surface manipulation in any number of different sheet materials. Indeed, since the early 1980s, it has been my privilege to teach 'sheet manipulation' to many students of design as one of the basic vocabularies needed by any designer, whatever the sheet material may be (paper, fabric, metal, polypropylene, clay, hinged plywood and so on).

It seems clear now that in the future the practice of origami will divide: traditional notions of model-making using bases and conventional techniques will reside with the educators, therapists and commercial book and CD-ROM publishers, but the creative emphasis will lie on those creators who have a highly personal style that involves much manipulative finesse, extreme technical complexity or imaginative audacity. This creative work will remain difficult to contextualize as art, craft, design, model-making or puzzle-solving.

So what of the other manipulative paper arts? When folding a piece of paper, the action of folding must inevitably decrease the size and surface area of the paper. However, when cutting a piece of paper, the cut has the potential to be opened so that the paper occupies a greater area of plane, or volume of space, than before. Thus, folding and cutting can be said to be opposites: one contracts the sheet, the other expands it. In this way, origami is fundamentally different to all the other paper arts, all of which employ cutting in some way.

Because they use a combination of folding and cutting, these other paper manipulation techniques are less distinctive than origami, less easy to define, more open-ended and often less geometric. Terms such as 'pop-ups', 'paper sculpture' and 'paper engineering' may be understood by some, but, ultimately, it is the quality of the work that speaks, not the technique.

In recent years, all the manipulative paper-art techniques have enjoyed a revival in interest, both as an amateur hobby craft and as a creative profession. Inevitably, a professional such as myself will begin to speculate about the reasons for this new interest. My own belief is that in today's increasingly computer-controlled, battery-operated, push-button society, in which the technology that oversees all our lives is beyond the understanding of all but a very few highly trained individuals, the absolute technical ordinariness of cutting and folding paper can be immediately understood by anybody of any age or culture, no matter how simple or complex a piece may be. In this way, objects made by manipulating paper can be directly appreciated by everyone – not just by an élite, educated in the visual rhetoric of art, craft and design – because we all fold and cut paper in our everyday lives. It is my view that the magic and universal appeal of paper manipulation will help consolidate it worldwide as a subject worthy of creative study in art, craft, design, education, therapy and science, and that this study will continue to grow and diversify.

SECTION ONE : TEXT AND MESSAGE

The very origins of paper are based in the need to record and deliver information. It is tied to the administration and government of our civilizations, our monetary systems, the education of our children, the research of academics and to the establishment of our cultural identities. In its rôle as a carrier of text and images it has lubricated the development of our social structures.

Through its appropriation into the visual arts as a material in its own right, the physical nature and structure of paper has been explored. Still, although they employ the particular characteristics and aesthetic qualities of paper as a material, many artists, designers and craftspeople are not only aware of, but also exploit the inferred meanings associated with the histories of its origin. This may vary from direct references to texts, documents and books to the more subliminal development of personal codes and vocabularies.

The work in this section is about language: public and private, constructed and deconstructed. The very forms of the paper-made devices we use to convey information are explored as objects, their physical and aesthetic presence taking precedence over function. Text becomes subtext, and the visual language of form becomes the tool of communication.

Cas Holmes, Deb Rindl and Les Bicknell exploit the sculptural possibilities of the book form. Meanwhile, Carl Jaycock and Jennie Farmer take found books and deconstruct them. The meanings of their texts are subverted and presented in a new form. The desire to read the work in a literal way is suppressed and controlled through how much the new composition allows us to see.

Although the content of the collected papers and documents that form the work of Graham Hay and Andrea Stanley holds particular significance, again, legibility becomes almost irrelevant. It is the evidence of text that is important, an imprint of its former meaning. In Jacki Parry's series Ways of Editing the need for text is dispensed with altogether, and her experiences and environment are described through a highly developed vocabulary of forms.

SECTION ONE : TEXT AND MESSAGE

Jacki Parry
Ways of Editing, 1996
Cast handmade paper
20 × 45 × 5 cm

Jacki Parry
Ways of Editing, 2000
Cast handmade paper
25 × 55 × 5 cm

Jacki Parry
Ways of Editing, 1998
Cast handmade paper
16 × 45 × 5 cm

Jacki Parry
Ways of Editing, 1998
Cast handmade paper
16 × 45 × 5 cm

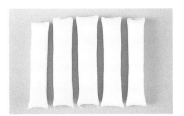

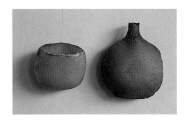

Jacki Parry
Ways of Editing, 1998
Cast handmade paper
9.5 × 19.5 × 5 cm

Jacki Parry
Ways of Editing, 1998
Cast handmade paper
16 × 30 × 5 cm

Jacki Parry
Ways of Editing, 1998
Cast handmade paper
16 × 30 × 5 cm

Jacki Parry
Ways of Editing, 1995
Cast handmade paper
10 × 20 × 5 cm

'Jacki Parry's work requires a form of reading without words. Even though the
sentences and phrases which construct her statements are produced with
and on paper, a language of forms replaces words as the principal tools of her
work. Each distinct element within the work relies in the final display on a
grammar across the work which involves repetition, intervals, stop signs, and
the viewer's recognition of a movement across shapes and meanings.'
**Katy Deepwell, Jacki Parry, *Ways of Editing: Works in Handmade Paper*,
Glasgow 1999**

SECTION ONE : TEXT AND MESSAGE

Graham Hay
Goodbye, 1998
Art documents, glued and
tooled
14 × 17 × 37 cm

below right
Graham Hay
Goodbye, 1998 (detail)

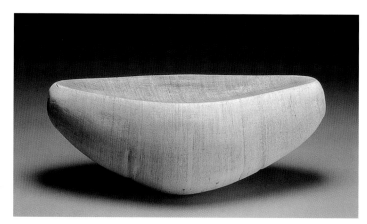

Graham Hay
Record, 1998
Art documents,
glued and tooled
60 × 60 × 25 cm

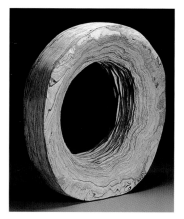

'Having used paperclay for over four years now I find myself increasingly considering sources of paper and its rôle in our daily lives. Despite the promise of an electronic society, the computer has increased the volume of paper we daily handle. Without paper, whole administration and knowledge systems would collapse. More specifically, for artists paper is essential.'
Graham Hay

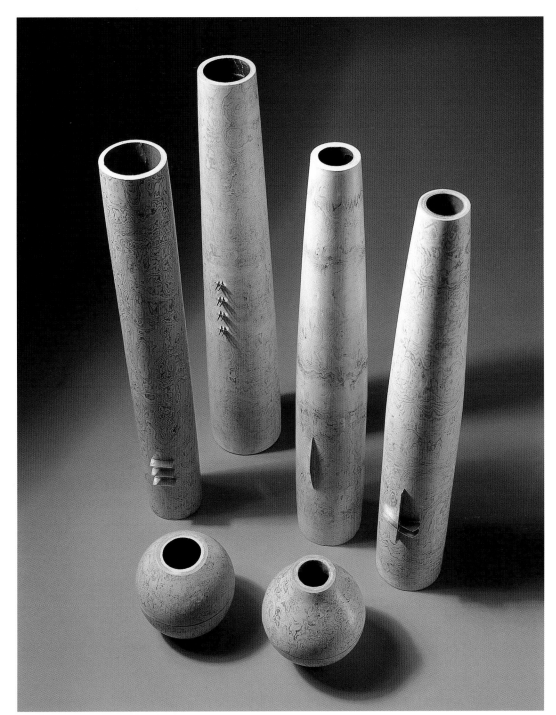

Andrea Stanley constructs her papier-mâché vessels using newspapers. The selection of texts is important, although the finished turned surfaces show only glimpses of words and phrases. The contours of the form create a map-like pattern. A cut is made in one side and the piece pulled from the wooden former. In the finished work this cut is not disguised, but forced open or held shut by means of simple metal clips and gadgets, providing a point of tension in an otherwise simple form.

Andrea Stanley
Turned Paper Forms,
1999–2001
Newspaper and magazines
Height 15–45 cm

Andrea Stanley
Turned Paper Form, 1999
(detail)

SECTION ONE : TEXT AND MESSAGE

Andrea Stanley
Turned Paper Form, 2001
Newspaper and magazines
15 × 12 cm diameter

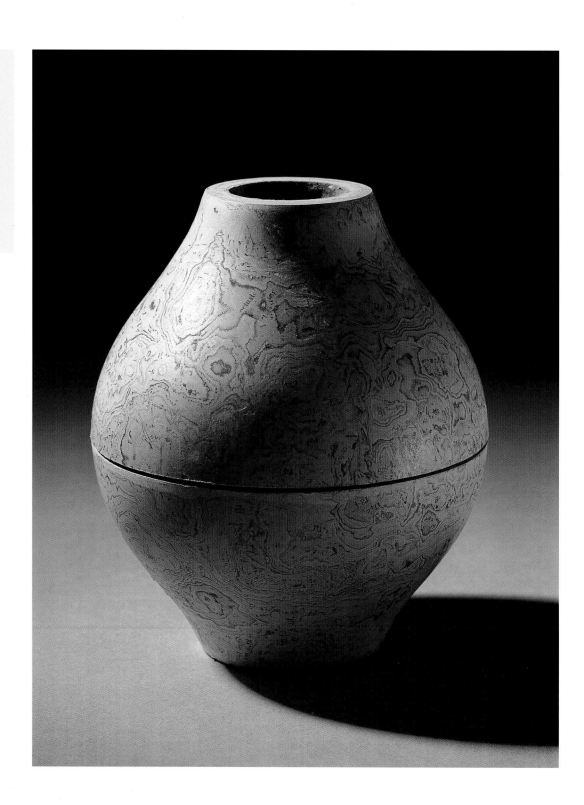

'Knowledge and the classification of knowledge have interested me for some time. I have been exploring books as vessels for this knowledge.
I am particularly interested in reference books – dictionaries, encylopaedias, books of knowledge – that offer to provide you with all you need to know in life.'
Jennie Farmer

Jennie Farmer
Folded Books, 2000
Manipulated book
Height 20–25 cm

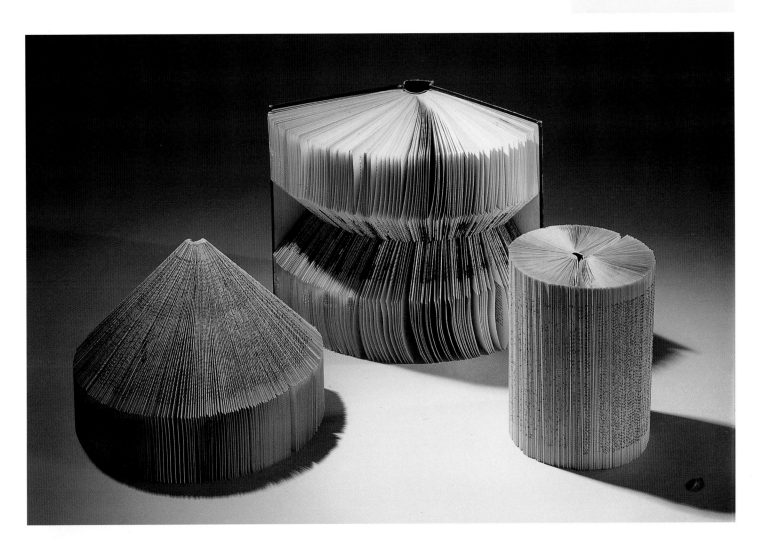

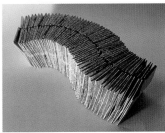

Jennie Farmer
The Mini Oxford Encyclopaedic Dictionary, Vol. 5, 2000
Manipulated book
6 × 9.5 × 25 cm

Carl Jaycock's work has been strongly influenced by the Thiapusam festival of South-East Asia. During the processions, devotees in trance-like states march to shrines with fruit, limes and other objects hanging from hooks that pierce the skin. These are penance offerings to the Hindu god of nature and eternal beauty.

Carl Jaycock
Francis Xavier II, 2000
Book pages, computer-generated images on acetate, and postcards
190 × 160 × 8 cm

right and far right
Carl Jaycock
Francis Xavier and many seeds, many religions, 2000 (details)
Book pages, computer-generated images on acetate, and postcards
190 × 160 × 8 cm

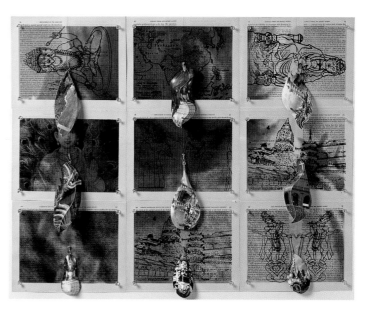

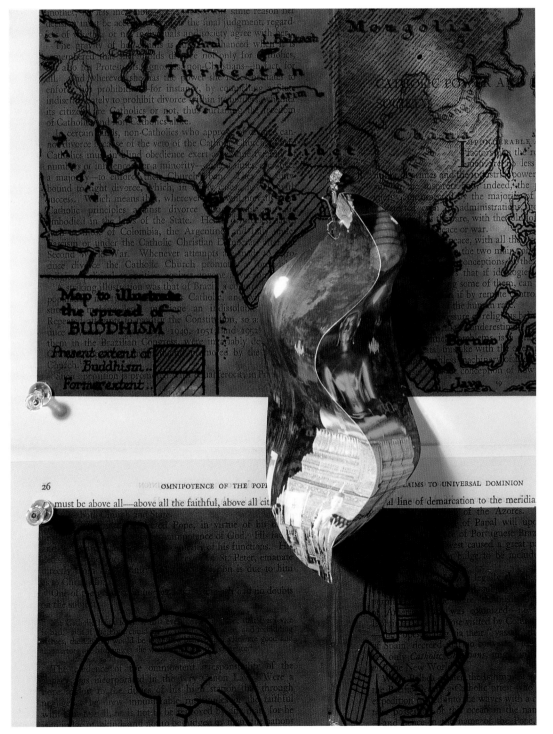

'I use paper for its versatility and the various forms it takes to communicate ideas and information. My specific focus on paper has been on its relationship to book pages, its quality and the way it discolours and echoes age and time.'
Carl Jaycock

SECTION ONE : TEXT AND MESSAGE

Deb Rindl
The Human Chain, 2000
Artist's book, edition of fifteen
13 × 35 × 16 cm

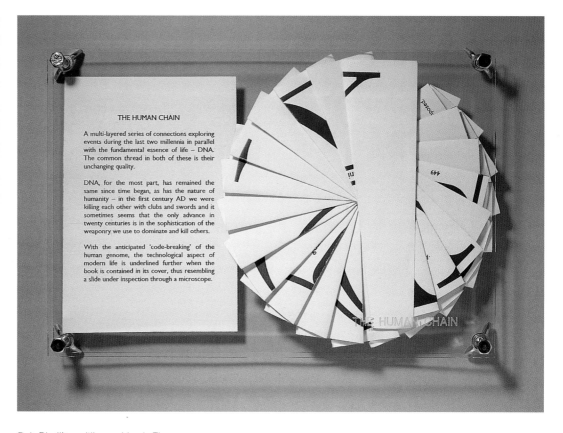

THE HUMAN CHAIN

A multi-layered series of connections exploring events during the last two millennia in parallel with the fundamental essence of life – DNA. The common thread in both of these is their unchanging quality.

DNA, for the most part, has remained the same since time began, as has the nature of humanity – in the first century AD we were killing each other with clubs and swords and it sometimes seems that the only advance in twenty centuries is in the sophistication of the weaponry we use to dominate and kill others.

With the anticipated 'code-breaking' of the human genome, the technological aspect of modern life is underlined further when the book is contained in its cover, thus resembling a slide under inspection through a microscope.

Deb Rindl's multilayered book *The Human Chain* explores events during the last two millennia in parallel with the fundamental essence of life – DNA. When held in its cover it resembles a slide for inspection under a microscope.

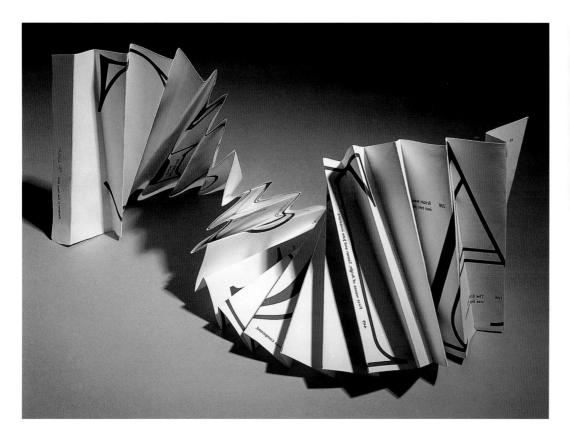

Deb Rindl
The Human Chain, 2000 (detail)

SECTION ONE : TEXT AND MESSAGE

'As a maker it is important to have a context to enable creativity. I make books, that is my framework, but this seemingly narrow working practice enables extensive exploration of the concept of the book: work that explores sequence, order, the idea of intimacy, narrative, time …'
Nicola Gray

Nicola Gray and Penny Baxter
Space Hotel, 2000
Artist's book
42.5 × 30.5 cm

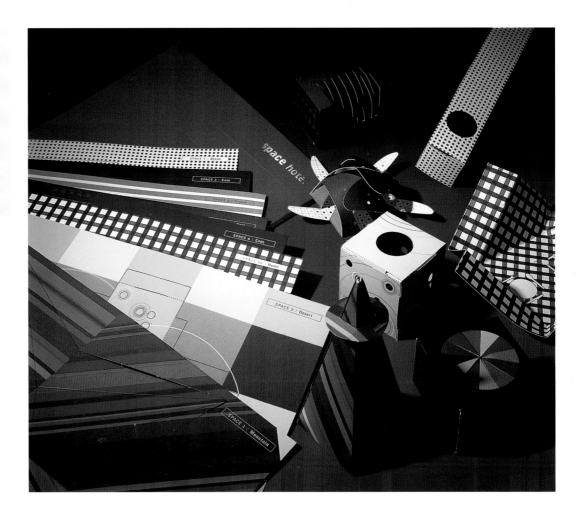

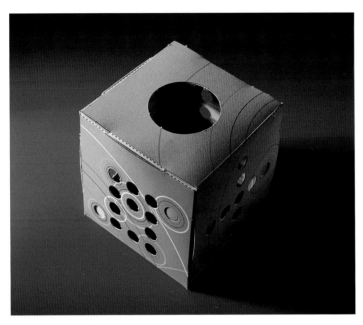

Space Hotel is a collaboration between Nicola Gray and Penny Baxter. Given an open brief to create a book for a touring exhibition, they designed an envelope containing ten A3 pages, each page representing a space – mountain, desert, cave, ocean, dream, nest, garden, home, city and cage. The paper sculptures are designed to work visually as flat graphic images as well as three-dimensional forms. There is no cutting or gluing involved in their construction; they utilize tucks, flaps and the paper's own tension.

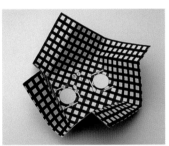

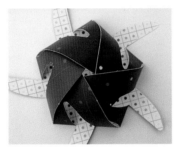

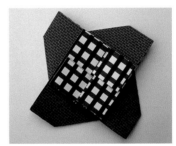

top
Nicola Gray and Penny Baxter
Space Hotel: Desert, 2000
Artist's book
6.5 × 6.5 × 6.5 cm

above centre
Nicola Gray and Penny Baxter
Space Hotel: Garden, 2000
Artist's book
6.5 × 6.5 cm

above left and right
Nicola Gray and Penny Baxter
Space Hotel: Home, 2000
Artist's book
14.5 × 14.5 cm

Cas Holmes
Slate-Book-Leaf, 2001
Slate and paper
6 × 160 × 12 cm open

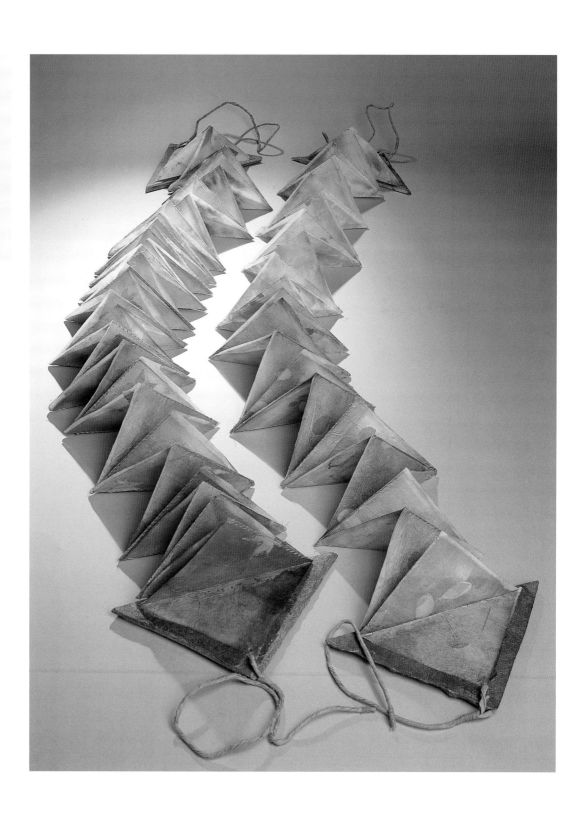

Cas Holmes has for many years developed a technique of layering and laminating different papers to create an almost luminous surface to her work. She uses mostly recycled and found paper, employing anything from sweet wrappers to tea bags. Her recent works draw on her knowledge of Japanese paper craft and explore the book form.

Cas Holmes
Slate-Book-Leaf, 2001 (detail)

SECTION ONE : TEXT AND MESSAGE

Les Bicknell and Matthew Tyson
Light Sheet, 1999
Handmade paper
150 × 150 × 170 cm

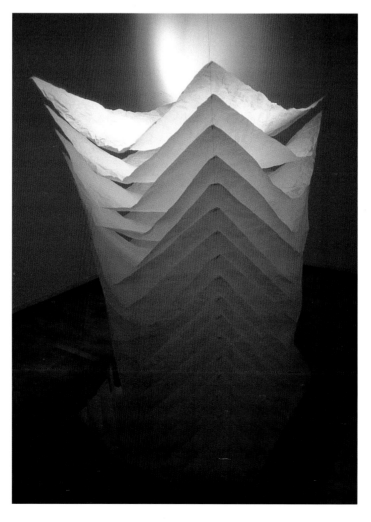

Les Bicknell is an established artist's book-maker, developing new ways of looking at the form, deconstructing and expanding the scale. Although the book is firmly at the centre of his practice, much of his work has been honed to a point where the sculptural qualities of the piece become the primary concern.

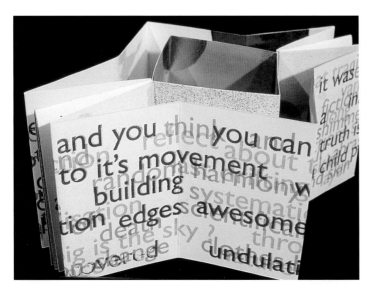

Les Bicknell
Cosmic Maths (1/20), 1990
Artist's book, edition of twenty
125 × 350 × 250 cm

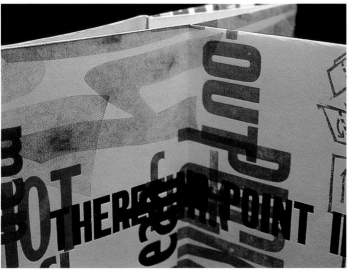

Les Bicknell
Idle Banter, 1993
Artist's book as two-dimensional
poster
19 × 14 × 0.3 cm

SECTION ONE : TEXT AND MESSAGE

Brian Robinson's work appropriates archive text paper into his sculptural practice; he is attracted by its utilitarian nature and lack of obvious beauty or texture. His work stands apart from the rest of this section in that he does not intend it to carry hidden messages or meaning, but to be read purely aesthetically.

Brian Robinson
(left to right)
no. 9, 2000, *no. 8*, 2000,
no. 5, 2000, *no. 1*, 2001
Archive text paper

Brian Robinson
no. 1, 2001
Archive text paper
207.6 × 51.9 × 2.6 cm

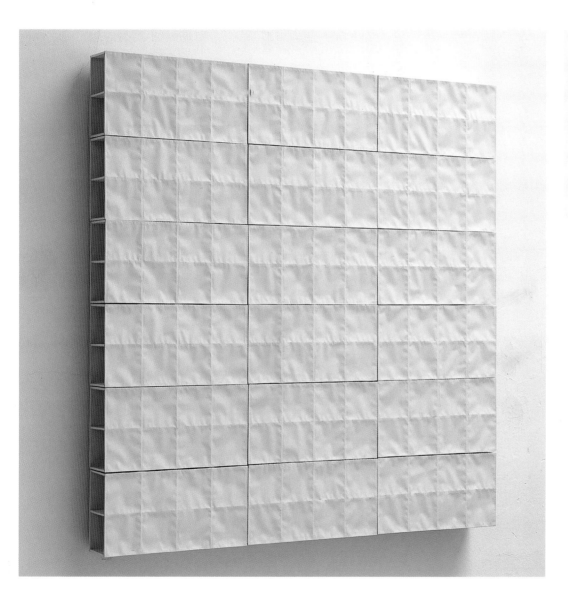

Brian Robinson
no. 4, 2000
Archive text paper
103.8 × 103.8 × 8.9 cm

'I want the way the works look to
be the result of the processes
involved in their making: necessary
processes to do with strengthening
and supporting rather than
embellishing.'
Brian Robinson

SECTION TWO : NEW FOLDING

The simplest and most immediate way in which we can interact with paper is to crumple or fold it. In its purest form, origami is the art of sculpting paper using only folds, without cutting, gluing or fastening – a direct interaction with the material.

Origami has mass appeal because, with just a little instruction, anyone can do it. And yet, in the most skilled hands, the most astonishingly accomplished results can be achieved. Akira Yoshizawa, known as *sensei* (master), takes the genre beyond purely representational model-making to create work that is gestural, suggesting movement and life.

This traditional Japanese folk art has provided a legacy on which contemporary artists have continued to build. Today, paper folding is employed in graphic and product design, packaging, craft and fine art, and a new Western practice of paper folding is developing, the focus of which is based in visual aesthetics rather than technical accomplishment. Although many of the structures remain complex, these artists are not concerned with the 'cleverness' of construction, but rather with the impact of the finished work. This is what has set Akira Yoshizawa's work apart within the field of origami, and why he remains a major influence on contemporary paper folding.

Jean-Claude Correia, Paul Jackson and Vincent Floderer draw their inspiration from the mathematics and repeated forms found in the natural world, resulting in organic abstract forms. Meanwhile, the mathematical and geometric aspects of plotting points and planes are used by Tomoko Fuse to create her much-copied modules, and by Damian Cruikshank in his engineered objects. Each is aiming to test the possibilities of the material.

SECTION TWO : NEW FOLDING

Akira Yoshizawa is possibly the most
prolific origami artist ever. The
legacy of work he has created
over many years has provided a
foundation from which contemporary
paper-folded art has evolved.

Akira Yoshizawa
Swans, 1980
Origami
Height 5–14 cm

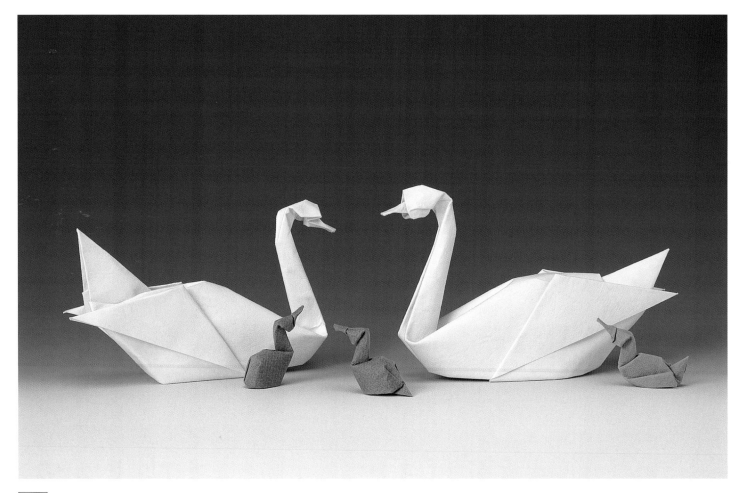

Akira Yoshizawa
Tumbling Figures, 1981
Origami
15 × 8 × 8.8 cm each

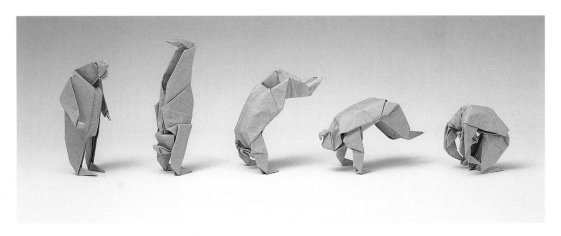

Akira Yoshizawa
The Legend of the Foundation of Rome: Romulus and Remus, 1987
Origami
13 × 22 × 6 cm

SECTION TWO : NEW FOLDING

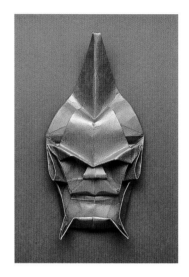

Akira Yoshizawa
Mask: Knight, 1968
Origami
22 × 11 × 3 cm

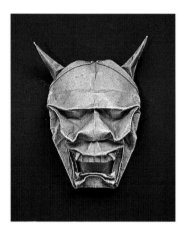

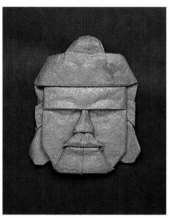

far left
Akira Yoshizawa
Mask: Hannya, 1955
Origami
17 × 13 × 15 cm

left
Akira Yoshizawa
Mask: Buddha, 1958
Origami
20 × 17 × 3 cm

'Origami is figurative representation through the structure of folded lines.
When I make a natural form, it becomes a lively realistic model because I
construct folding lines that comply with the laws of nature. When I choose the
way of representation, whether symbolic or abstract, it sometimes turns out as
I want, and at other times only after many trials and errors.'
Akira Yoshizawa

Eric Joisel is one of the growing numbers of artists developing a European sculptural origami practice. Having worked with clay, his approach to paper is modelled, often using wet-paper techniques.

'My models are always conceived with precise geometrical creases, but during the folding process I often use curves and not straight lines, so that they are not really flattened creases. I often deconstruct the initial creases to obtain life in the model.'
Eric Joisel

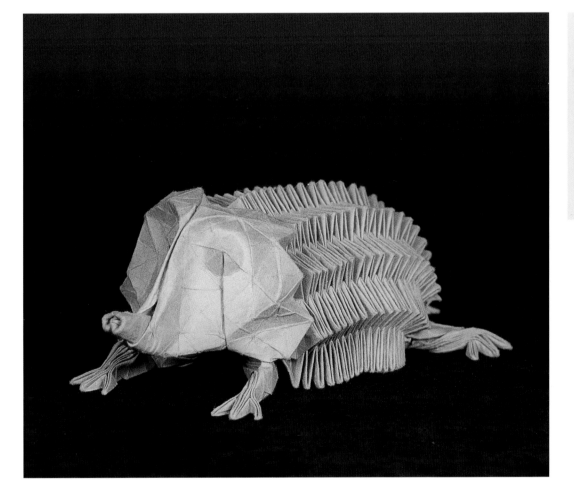

Eric Joisel
Hedgehog, 1999
Origami
5 × 8 × 5 cm

SECTION TWO : NEW FOLDING

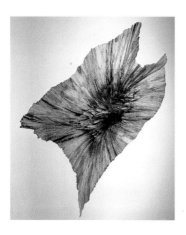

Vincent Floderer
Boom, 2000
Crumpled paper
50 × 65 × 10 cm

Vincent Floderer
Boom, 2000 (detail)

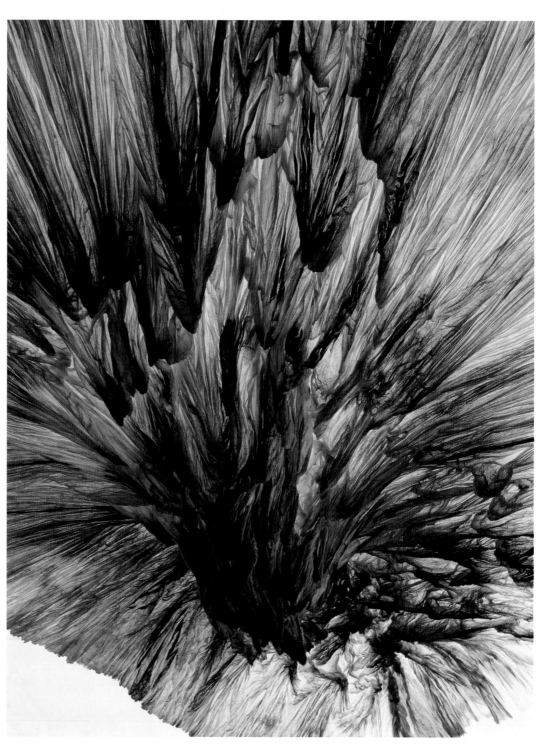

Vincent Floderer explores natural form through representational and abstract compositions. He has taken the technique of crumpling, and refined and developed it to become one of its foremost exponents.

Vincent Floderer
Longicornes 'La Grande Panovillerie', 1997
Origami
35 × 45 × 5 cm (boxed)

Vincent Floderer
*0/24*Δ,* 1999
Brown paper and linseed oil
65 × 50 × 10 cm

SECTION TWO : NEW FOLDING

Jean-Claude Correia's relationship with paper is instinctive. His dexterity in manipulating and folding frees his imagination, and he believes his most creative work is accomplished when he allows the forms to develop naturally. Even so, this is a time-consuming process, with each piece taking up to two months to finalize, the journey being punctuated by hesitations and choices.

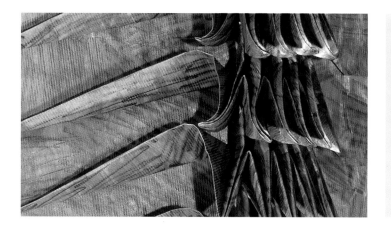

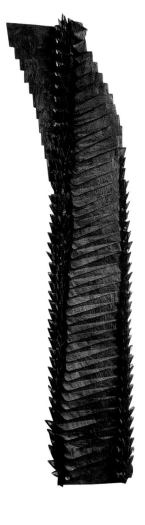

Jean-Claude Correia
Pilage rouge, Février, 1998
Craft paper, crayon and acrylic
300 × 60 × 10 cm

left
Jean-Claude Correia
Pilage rouge, Février, 1998
(detail)

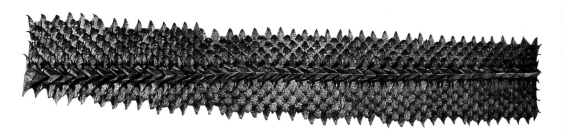

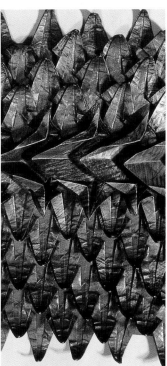

Jean-Claude Correia
Blue Horizon, 1997
Craft paper, crayon and acrylic
60 × 320 × 10 cm

right
Jean-Claude Correia
Blue Horizon, 1997 (detail)

SECTION TWO : NEW FOLDING

'My work is influenced by theories of
cellular growth, in which sheets of
cells slide over other sheets in
certain directions, giving form to an
initially unspecific embryonic ball of
cells. My work passes through this
unformed stage of making, and is
pulled into shape by parts of the
sheet sliding past other parts. In this
way, many of the forms resemble
abstractions of natural forms,
because they grow in the same way.'
Paul Jackson

Paul Jackson
Single Crease Form, 1999
Paper
15 × 20 × 20 cm

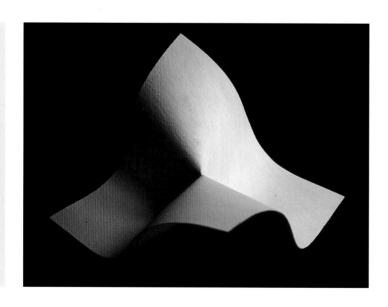

Paul Jackson
Untitled, 1998
Paper and dry pastel
24 × 30 cm diameter

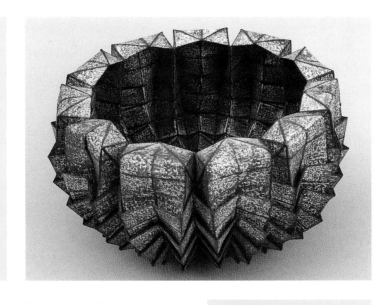

Paul Jackson
Untitled, 1998
Paper and dry pastel
20 × 30 cm diameter

SECTION TWO : NEW FOLDING

Tomoko Fuse
Unit Boxes, 2000
Paper and perspex
8 × 8 × 8 cm each

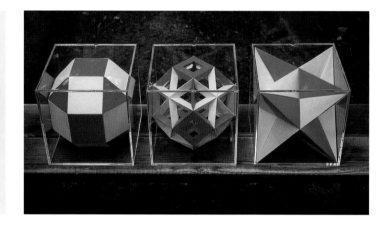

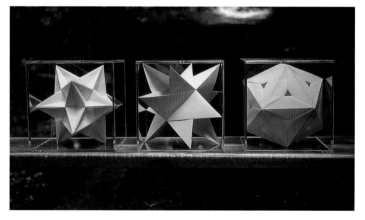

Tomoko Fuse was introduced to origami as a child during a stay in hospital. She quickly became an enthusiastic practitioner and specializes in unit origami: modules that are created from several pieces of folded paper.

Grace Clifford
Water Bombs, 2000
Screenprinted paper
5 × 5 × 5 cm each

The construction methods for the water bombs were taken from the book *Teach Yourself Origami* by Robert Harbin, London 1992.

'I see the works as three-dimensional drawing – like the everyday environments that inspire me, they constantly move and evolve. I build environments by bringing together an amalgamation of multiple and solitary paper objects within a given space.'
Grace Clifford

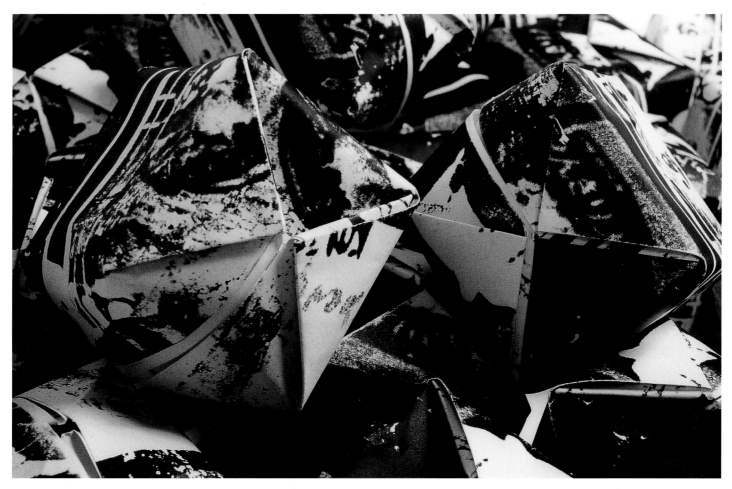

SECTION TWO : NEW FOLDING

Carol Andrews
Paper Wrap, 2000
Paper
80 × 60 × 60 cm

Carol Andrews
Paper Wrap, 2000 (detail)

Damian Cruikshank
Pillar, 2000
Card
Height 429 cm

'Spatial concerns are most important to my work. Paper Wrap is about enclosing space within a protective layer that suggests inaccessibility and a precious place. The viewer is seduced by the strange texture into peeping inside and unlocking the visual puzzle.'
Carol Andrews

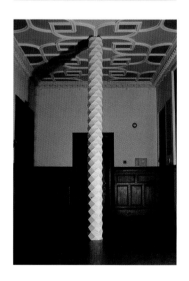

'My working practice draws on many aspects of the visual arts. Success requires problem-solving skills, a working knowledge of materials and processes as well as the ability to present work in an appropriate manner. I enjoy manipulating and exploiting a material's properties. Paper manipulation produces unexpected forms, which fuel further research. The completion of one model informs the approach to be taken with the next, producing families of forms with shared and opposing qualities. Fresh insights occur when shapes are compromised in some way.'
Damian Cruikshank

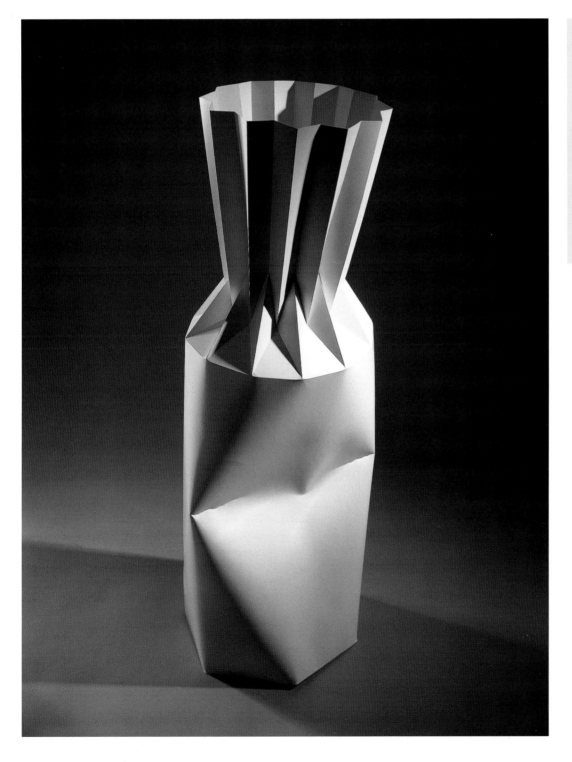

Damian Cruikshank
Dented Form, 2000
Card
Height 68 cm

SECTION THREE : CUT AND CONSTRUCTED

As the sculptural applications of paper continue to be exploited, practitioners from disciplines as diverse as textiles, product design, ceramics and sculpture have been seduced by its flexibility and tensile strength. Although traditionally considered a transient material, it has been employed in areas normally associated with durable media, such as architectural structures and features, and furniture.

Structure, strength and construction processes are explored in the work grouped in this section. In addition to multiple folding, the means of constructing form are expanded through cutting, gluing, stitching, weaving and riveting.

There is a strong relationship between the work in this section and textile practice. Jozef Bajus has an established profile within the arena of Eastern European fibre arts, but for some years has used paper as a main material. Jess Ahmon and Charlie Thomas all use stitching, and to some extent tailoring, as essential elements of their work.

Lois Walpole and Penny Burnfield employ basket-weaving techniques. Jewellers Julia Keyte and Alison Wilson-Hart both layer paper to different effect: while Keyte utilizes different paper surfaces, Wilson-Hart's tactile neckpieces use a ruff-like structure to create texture.

Texture is handled in a very different way by Peter Niczewski and Paul Johnson. Both use cutting, scoring, folding, curling and gluing to form intricate compositions. Niczewski's white paper flowers work best as large, extravagant displays. Paul Johnson's work shares that exuberance, incorporating bright colour into the mix. Both his free-standing models and relief book works have a manic and eccentric appeal. At the other end of the spectrum, Tetsuji Kawamura's lamps exploit the simplicity of a single cut.

SECTION THREE : CUT AND CONSTRUCTED

Charlie Thomas has a fascination with apparel and employs pattern-making, cutting and sewing techniques in the construction of his own witty take on the fashion industry.

Charlie Thomas
*Womens- and Menswear
Autumn/Winter 1999/2000,*
1999
Photograph
150 × 122.5 × 0.5 cm

far right
Charlie Thomas
*Womens- and Menswear
Autumn/Winter 1999/2000,*
1999 (detail)

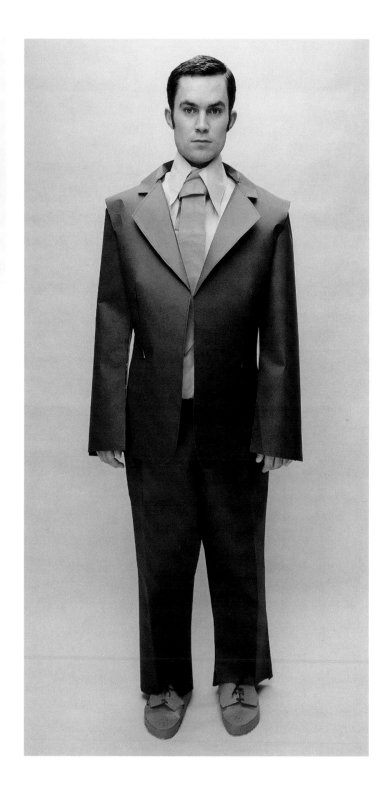

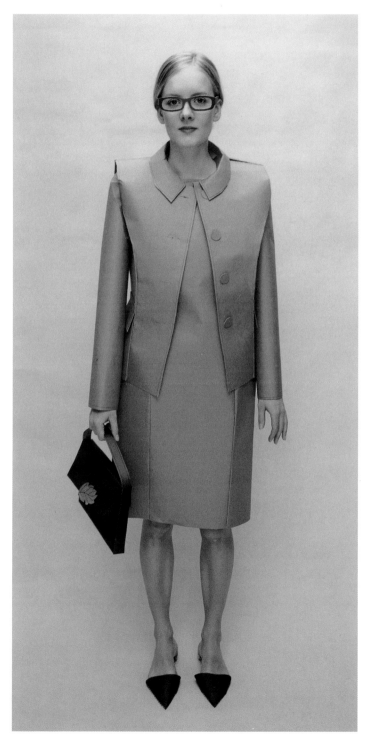

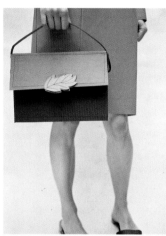

SECTION THREE : CUT AND CONSTRUCTED

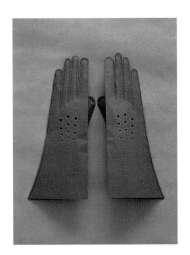 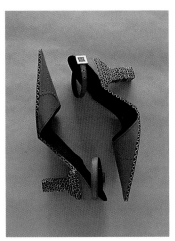 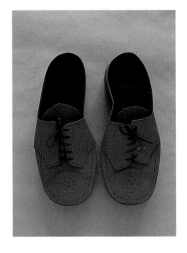 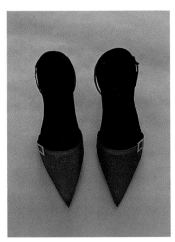

'Although I had a graphic-design training, I have since worked closely with fashion designers, interior architects and photographers, and there are elements of all of the above disciplines in my work. I am fascinated by the workings of the apparel/fashion industry. Colour has always played a large part in my work, and this is a fundamental trait of the fashion industry too.'
Charlie Thomas

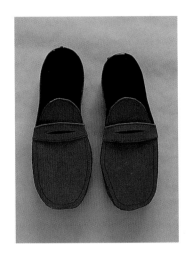

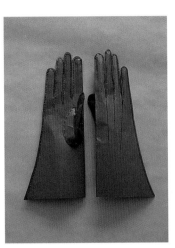

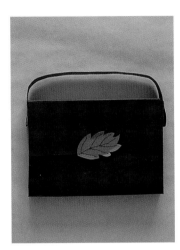

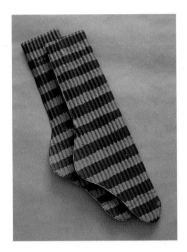

Charlie Thomas
*Accessories Autumn/Winter
1999/2000*, 1999
Various papers and cardboard

Alison Wilson-Hart
Backpiece, 2000
Drilled and threaded paper
8 × 1.5 × 110 cm circumference

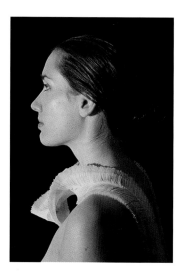
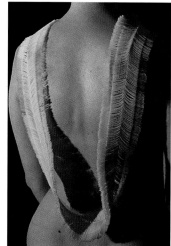

'The levels of opacity and translucency resulting from these methods create the linear pattern. The subtleties of these techniques require a sympathetic use of colour, and, as such, I concentrate on different papers and shades of white, which emphasize the sculptural aesthetic of my work.'
Alison Wilson-Hart

Alison Wilson-Hart's collection of jewellery uses precise cutting, folding and layering techniques.

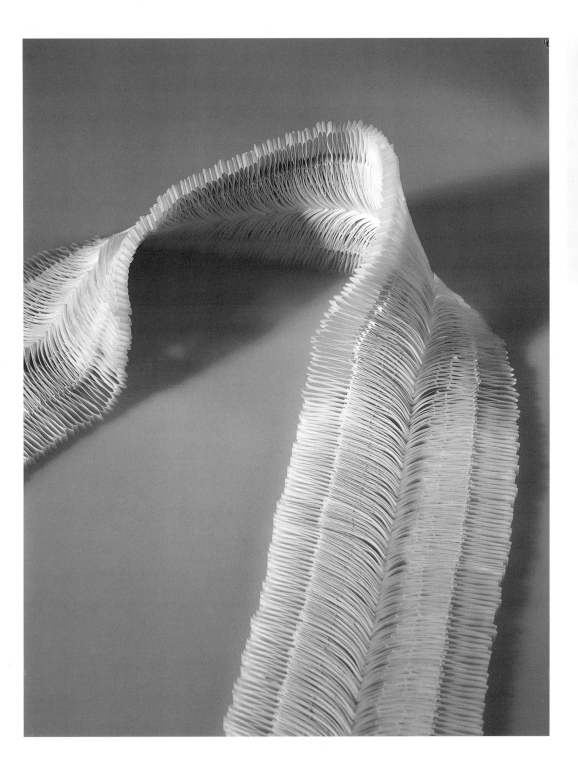

Alison Wilson-Hart
Backpiece (detail), 2000

SECTION THREE : CUT AND CONSTRUCTED

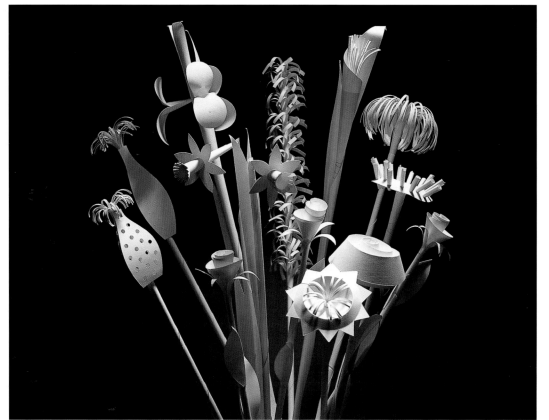

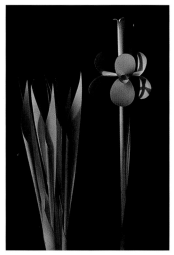

Peter Niczewski has an established reputation for working in wood and wood inlay. However, for the past three years he has been working exclusively in paper, reinventing his practice. These flower pieces are unashamedly decorative and have the strongest impact when seen within an extravagant display.

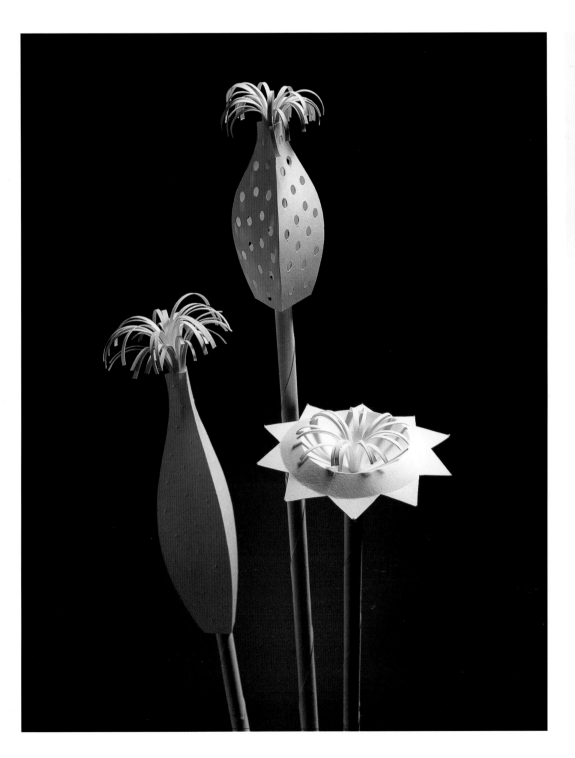

SECTION THREE : CUT AND CONSTRUCTED

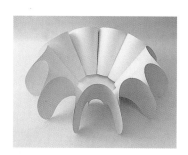

Scale is important to Jess Ahmon. She prefers to work on as large a scale as the paper will allow, in order to force the viewer to walk around the piece and to remove references to domestic or hand-held objects.

Jess Ahmon
Moulin, 2000
Cut and sewn paper
20 × 61 × 61 cm

Jess Ahmon
Moulin, 2000 (detail)

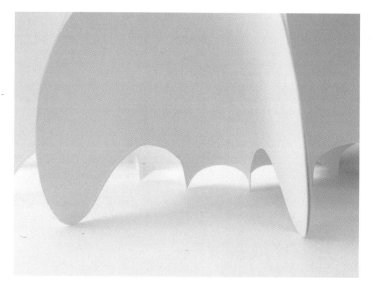

'Paper's minimal qualities, two surfaces and an edge, appeal to me, and I see abundant possibilities for sculptural forms precisely because of its limitations. I find it a satisfying material to work with, mainly because of its crispness and simplicity. I want the paper to dictate the form, so I deliberately limit the ways in which I control it. I use only scissors and a sewing machine, although a stapler comes in handy when I am experimenting. I never use glue as I find the moisture causes the paper to behave unpredictably.'
Jess Ahmon

Julia Keyte
Brooch Experiments, 2001
Tracing paper, tissue, Tipp-Ex
and fabric
5–6.5 cm diameter

Julia Keyte
Paper Experiment 1, 2001
(detail)
Tracing paper, tissue, Tipp-Ex
and fabric
5 × 5 × 0.4 cm

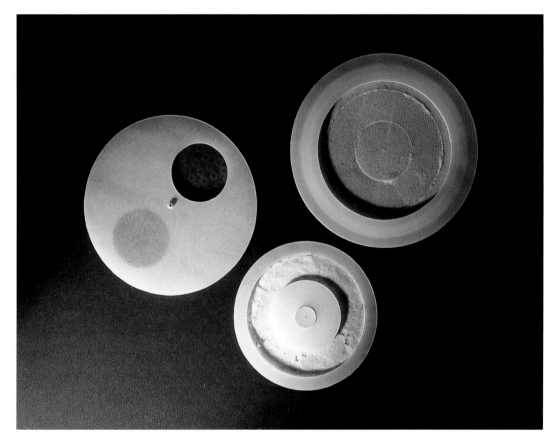

'I enjoy the immediate nature of working in paper. I use a variety of basic
papers (such as cartridge, lined and tracing paper) and paper-like materials, in
combination with other materials such as fabrics, varnishes and lacquers, as
canvases for exploration and manipulation. I incorporate such processes as roll
printing (which creates subtle and delicate patterning, often lacy in nature), or
intricate cutting and layering. I have always been captivated by the translucency
and strength of tracing paper and its ability to lend itself to construction.'
Julia Keyte

SECTION THREE : CUT AND CONSTRUCTED

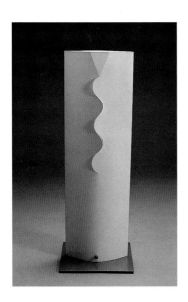 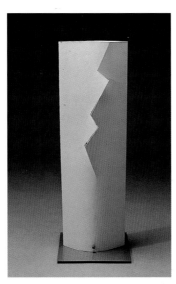

Tetsuji Kawamura
Bonbori Lamps, 2000
Paper fibre
51 × 18 cm each

Tetsuji Kawamura is a Japanese product designer who has continued to use the traditional material of paper to create lamps, screens and plates. The simplicity of his cut-paper lamps in terms of design and construction is very modern. The choice of material allows a soft, warm light to emanate from these very crisp, minimal forms.

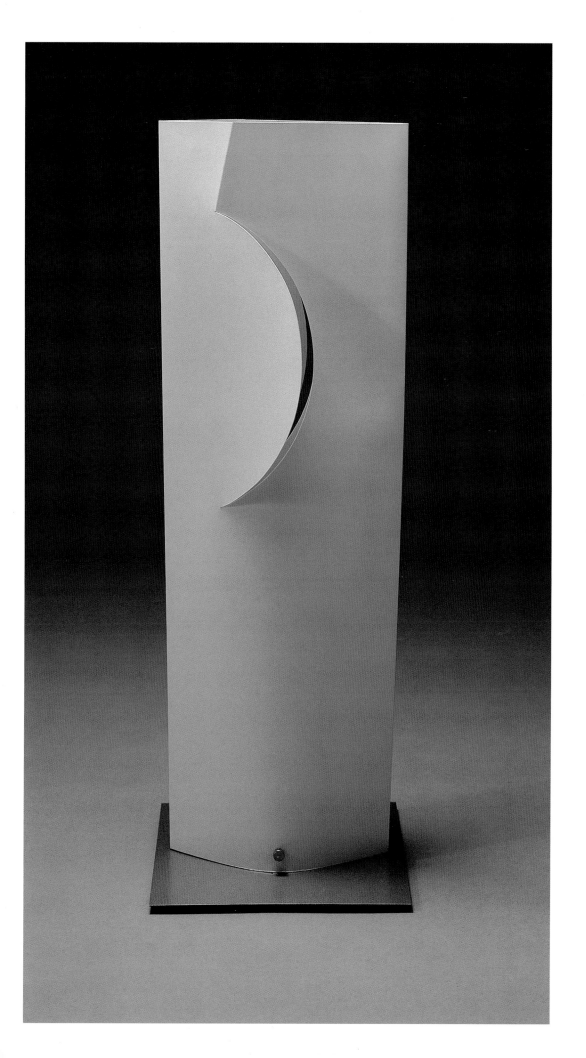

Penny Burnfield
Bastion, 2001
Paper (Tyvek) and thread
35 × 35 × 35 cm

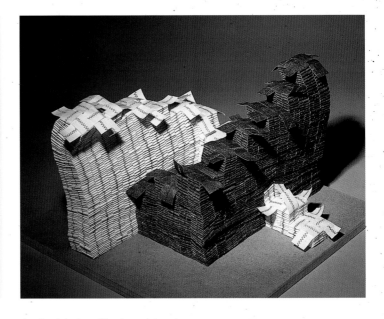

A retired doctor with a keen interest in biology, Penny Burnfield expresses her continued interest in experimentation and the exploration of the natural world and the human condition through her work. She draws inspiration from biological segmented forms, as well as fundamental architectural forms, ritual buildings, ancient cultures and human endeavour.

'I am intrigued by the process of making – in three-dimensional geometry and the putting together of flat shapes to make something that is far more than the sum of its parts.'
Penny Burnfield

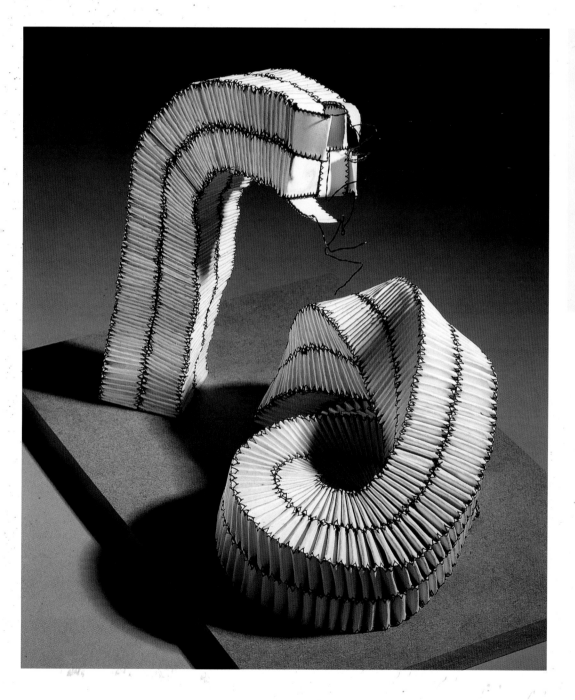

Penny Burnfield
I want to be alone, 2000
Paper (Tyvek) and thread
22 × 30 × 20 cm

Jozef Bajus
Fan I, 1999
Perspex, paper and cotton thread
17 × 42 × 3 cm

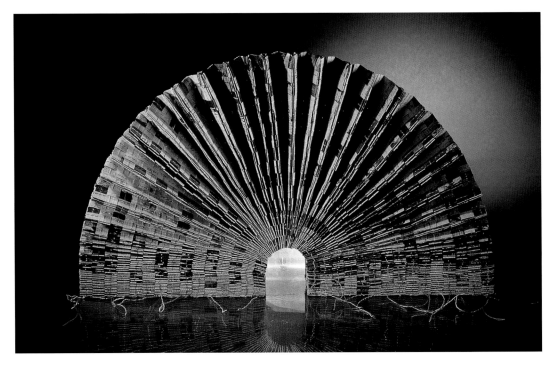

'Traditional methods of creating can be moved into new dimensions by searching and experimenting. Experiment and change fascinate me. Change is almost always connected with some surprise element, and many times it becomes the animating spirit of solving artistic problems.'
Jozef Bajus

Jozef Bajus
Grey Composition, 1996
Paper and staples
60 × 45 cm

Jozef Bajus works by cutting, tearing, stitching and stapling paper. Early works were very concerned with pattern, as a natural progression from his experience as a textile designer. As his practice has developed, concepts of human activity, both positive and negative, have influenced the nature of his work. The war in Kosovo and the Middle East conflict have both had an impact on his approach.

Jozef Bajus
Horizontal Meditation, 2000, and *Vertical Meditation,* 1999
Perspex, paper and cotton thread
12 × 15 × 7 cm
15 × 12 × 7 cm

SECTION THREE : CUT AND CONSTRUCTED

Paul Johnson
Pop-up Engineered Relief, 1999
Paper sculpture
53 × 80 × 6 cm

Paul Johnson
Pop-up Engineered Relief, 1999
(detail)

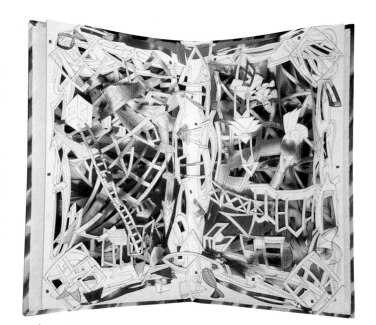

'The constructions comprise fifty or more paper units that create myriad layered levels of design. The artefacts themselves combine the two cultures of aesthetics and science – one has to be an engineer to make the whole creative idea come into being. Architectural concepts are the foundation of my work, although thematic ideas derive from natural forms, landscape and religious iconography.'
Paul Johnson

Paul Johnson has worked exclusively in paper since 1984. His work covers paper furniture, sculpture and book art. He combines his rôle of artist with that of teacher, author and lecturer in paper engineering.

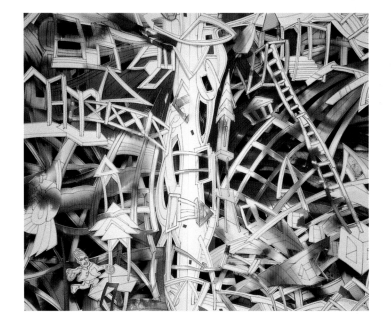

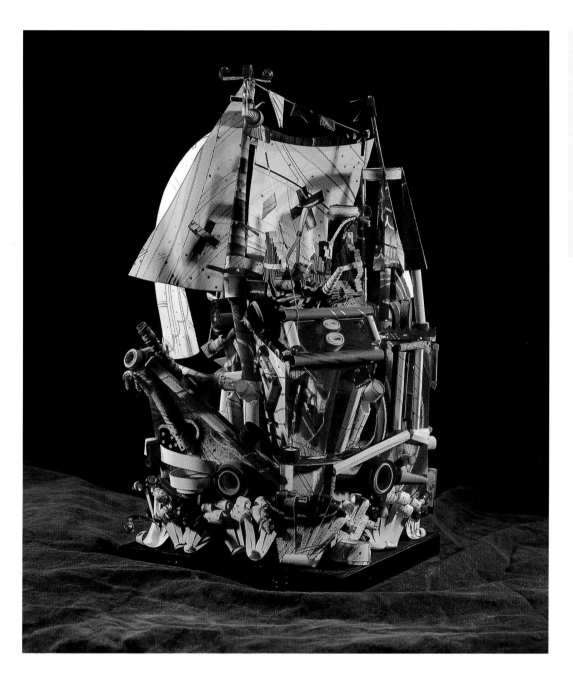

Paul Johnson
Once I travelled to the birth of my spirit, 1998
Paper sculpture
33 × 20 × 20 cm

SECTION THREE : CUT AND CONSTRUCTED

A desire to create a new aesthetic in basketmaking has been an overriding concern in the work of Lois Walpole. For over ten years she has made a conscious decision to use only recycled or found materials.

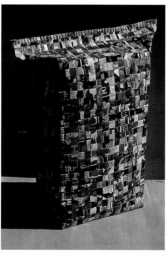

left
Lois Walpole
Laundry Basket, 1995
Card
90 × 79 × 35 cm

above
Lois Walpole
Basket, 1983
Paper and cardboard
31 × 32 × 32 cm

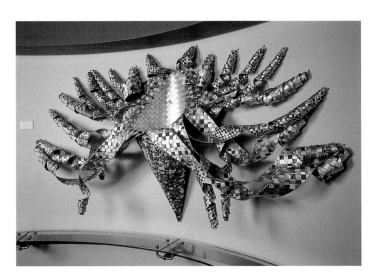

Lois Walpole
Commission for The Co-op
Headquarters, Rochdale, 1997
Paper and juice cartons
Width 120 cm

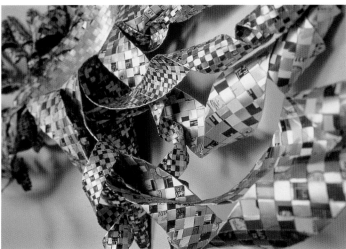

Lois Walpole
Commission for The Co-op
Headquarters, Rochdale, 1997
(detail)

'I use a wide range of recycled and natural materials. Paper is always available. I seem to be engaged in a constant battle to remove paper from my home, which relentlessly cascades through my letter box.'
Lois Walpole

SECTION FOUR : NATURE AND SPIRIT

In Eastern culture, white paper is a potent symbol of purity. It is used as an instrument of purification and exorcism, both in religious ceremonies and in everyday life. The artists in this last section are all concerned to some degree with a sense of spirit within their work – the human condition and our place within the natural world.

Identity is explored by Susan Cutts through her examination of social response to dress, while Karin Muhlert and Sue Lane address these issues of identity through personal concerns and experiences. The body and our attitudes to our physical selves are the subject of Jeanne Jaffe's work.

Placing ourselves within the natural environment has been a preoccupation for many artists. Nature offers myriad opportunities to explore our place in the world, whether through the science of nature, as in the work of Norie Hatakeyama, or through our experience of the elements, as explored by Kyoko Ibe.

Then there is the environment we make for ourselves: our domestic setting, the objects with which we surround ourselves and how we respond to those objects. Jon Atkinson plays with those relationships to disquieting effect.

SECTION FOUR : NATURE AND SPIRIT

'As my work is usually multiple and very labour intensive, I have time to think/dream while working, and although I tend to work through many ideas before arriving at the final piece, I always want to explore further.'
Susan Cutts

Susan Cutts
Stiletto, 1999–2000
Cast handmade paper
200 × 300 cm

Susan Cutts explores identity, both on a personal level and within a cultural and political context, through the imagery of dress. She explores the seductive shape of the shoe in her work *Stiletto*, and in her installation of near-identical paper shoes. There is a fragility and delicacy about the group, which has the feel of a flock about to take flight.

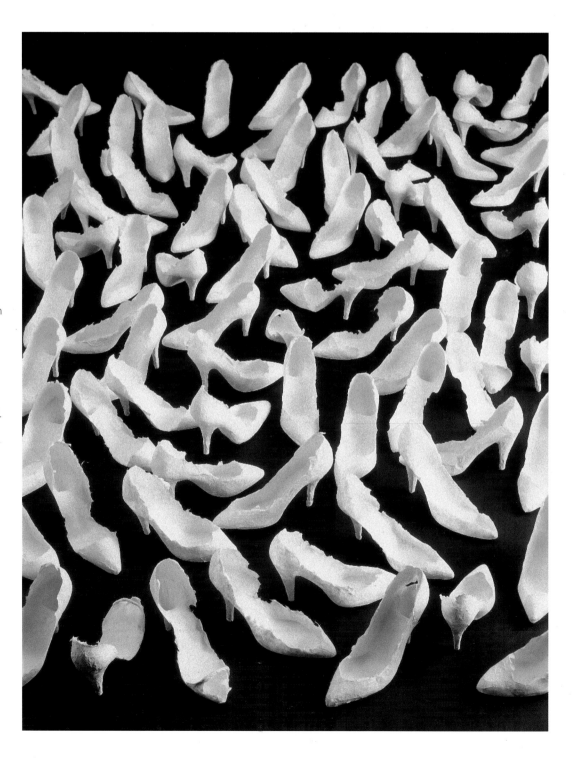

'The experience of being human comes together as different things. You are your own fusion of vegetable, animal and mineral. Body parts can be disoriented. You're not always in scale.'
Jeanne Jaffe

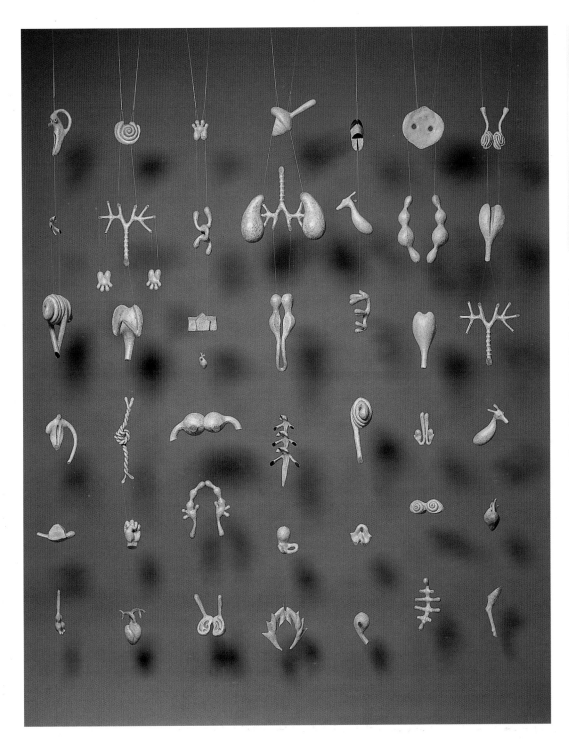

Jeanne Jaffe
Spill of Memory, 1988
Cast paper
171 × 110 × 25.4 cm

Jeanne Jaffe is a sculptor who works in a number of materials, including wood and bronze, but it was her cast-paper forms that first established her reputation. What attracted her to paper was the immediacy of being able to develop her imagery in a lightweight, manageable and cheap material. Although very light, the forms have a sense of gravity and scale. Jaffe's work varies from pieces that could easily be held in the palm of the hand to those of monumental scale.

SECTION FOUR : NATURE AND SPIRIT

Jon Atkinson's figurative pieces in paper have a sense of strangeness and of the surreal. He is a self-taught artist who for the past fifteen years has worked consistently to refine his skills in manipulating paper, making his task the creation of 'anything' in paper. His choice of subject-matter is ordinary, even mundane – the rusty kettle, the leather jacket, the clod of earth. Our perception of reality is engaged in a playful game.

Jon Atkinson
Dandelion, Grasses and Bumblebee, 1995
Paper and acrylic
16 × 12 × 10.5 cm

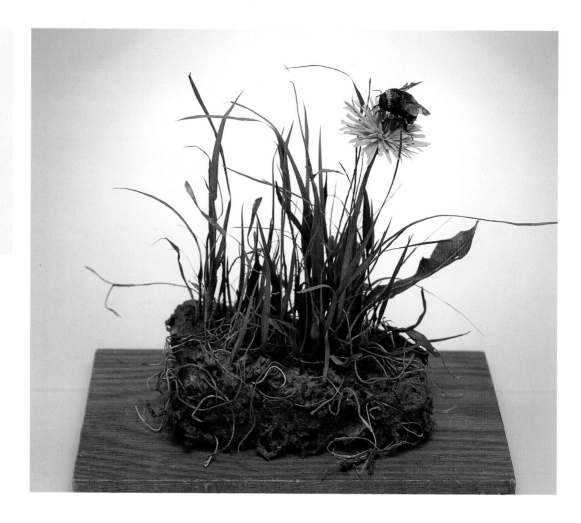

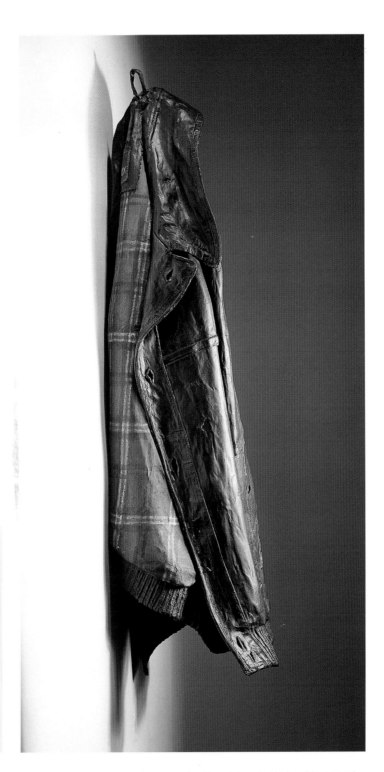

Jon Atkinson
Leather Jacket, 1990
paper and acrylic
90 × 33 × 23 cm

'I am interested in humble, natural and domestic objects. Because of the nature of my work, I am encouraged to look more closely at things.'
Jon Atkinson

SECTION FOUR : NATURE AND SPIRIT

During a research visit to a papermill, Karin Muhlert discovered stacks of discarded paper rolls. These became the basis of a new series of work. She found that working with the restrictions of these tightly wound rolls echoed physical restrictions in her own life, and this marked a new beginning in her work.

Karin Muhlert
Metamorphosis I©, 2000
Manipulated cut paper
13 × 20 × 20 cm

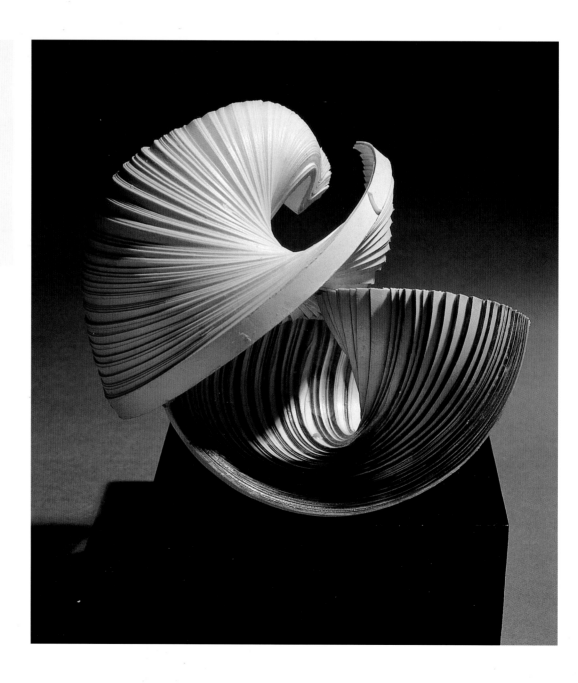

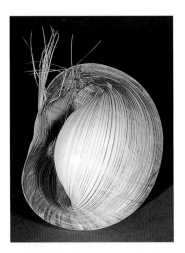

Karin Muhlert
Sea-Cell, 2000
Manipulated cut paper
22 × 11 × 20 cm

Karin Muhlert
Metamorphosis II©, 2000
Manipulated cut paper
13 × 20 × 20 cm

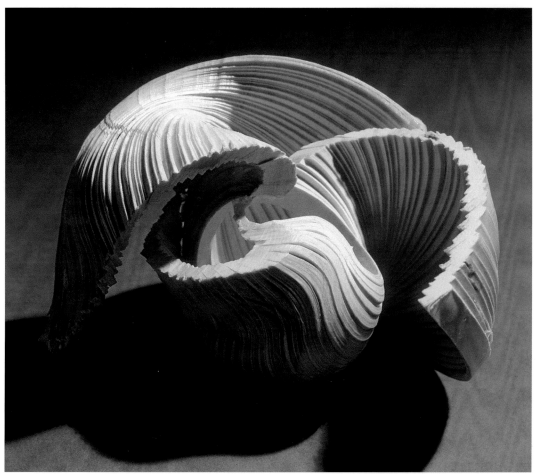

'To me, paper has a metaphoric
power that reveals something about
the self during the process of
making. I look upon the change and
transformation of one shape into
another, such as the collapsing of a
hollow form, as a metaphor for my
personal life experiences, such as
vulnerability, strength, rejection,
acceptance, dependence,
independence.'
Karin Muhlert

SECTION FOUR : NATURE AND SPIRIT

Angela O'Kelly
Purple and Grey Neckpiece,
1998
Paper
Diameter 38 cm
London, Crafts Council Collection

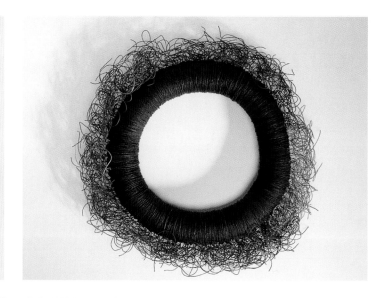

Angela O'Kelly
*Hundreds and Thousands
Neckpiece,* 1999
Discs of *The Financial Times,*
piano wire, silver and *mokuba*
paper
4 × 180 cm
London, Crafts Council Collection

Angela O'Kelly
Boa, 2000
paper
6 × 92 cm

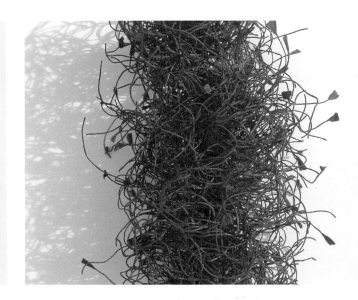

Angela O'Kelly
Neckpiece, 2000
Paper
Diameter 40 cm

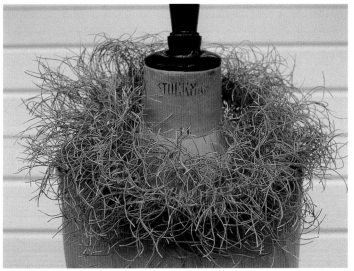

SECTION FOUR : NATURE AND SPIRIT

Norie Hatakeyama has placed the basket form at the centre of her creative expression. Its production by human hand, its appropriation of the geometry of nature, and the history of the basket from the ancient Greeks through to modern-day science and technology, bestow the form with meaning, providing Hatakeyama with an eloquent language of communication.

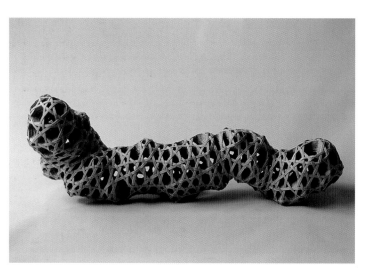

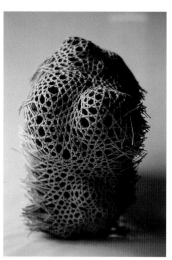

Norie Hatakeyama
Complex Plaiting, Connection I.9603, 1996
Paper-fibre strips
45 × 25 × 38 cm

Norie Hatakeyama
Complex Plaiting, Connection I.9508, 1995
Paper-fibre strips
25 × 73 × 20 cm

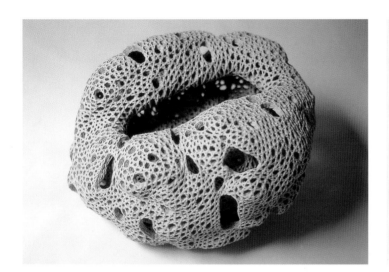

Norie Hatakeyama
Complex Plaiting, .9902, 1999
Paper-fibre strips
33 × 48 × 43 cm

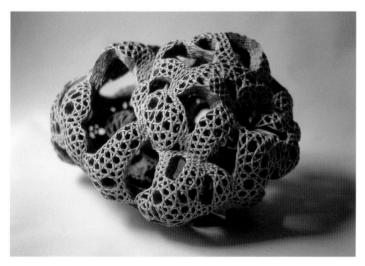

Norie Hatakeyama
*Complex Plaiting, One Hole
A.0001,* 2000
Paper-fibre strips
24 × 40 × 30 cm

'My work is created through the
observation of the relationship
between one entity and another,
interweaving each according to the
principles of basketmaking. I believe
that the nature of the fundamental
structure of the elements plays a
crucial role in the production
process. This is equivalent to the
fact that the existence of nature
depends upon individual existence
according to the rules and laws
imposed by nature itself.'
Norie Hatakeyama

SECTION FOUR : NATURE AND SPIRIT

Sue Lane
Free-standing set of three brooches, 2000
Paper, silver and glass
6 × 6 × 4 cm

As a jeweller, Sue Lane has been drawn to paper by its translucency and lightness. The forms are hollow and relate to the idea of seedpods, with secure nurturing spaces enclosed within.

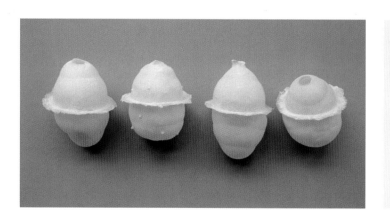

Sue Lane
Paper Forms, 2000
Paper
65 × 45 cm diameter each

'Some forms are not wearable, though they have tactile qualities. To place them in the hand gives the holder a feeling of their delicate strength and engages interaction between person and object. Precious qualities are important to me. Through material manipulation I have tried to create translucent, delicate forms that signify purity and preciousness.'
Sue Lane

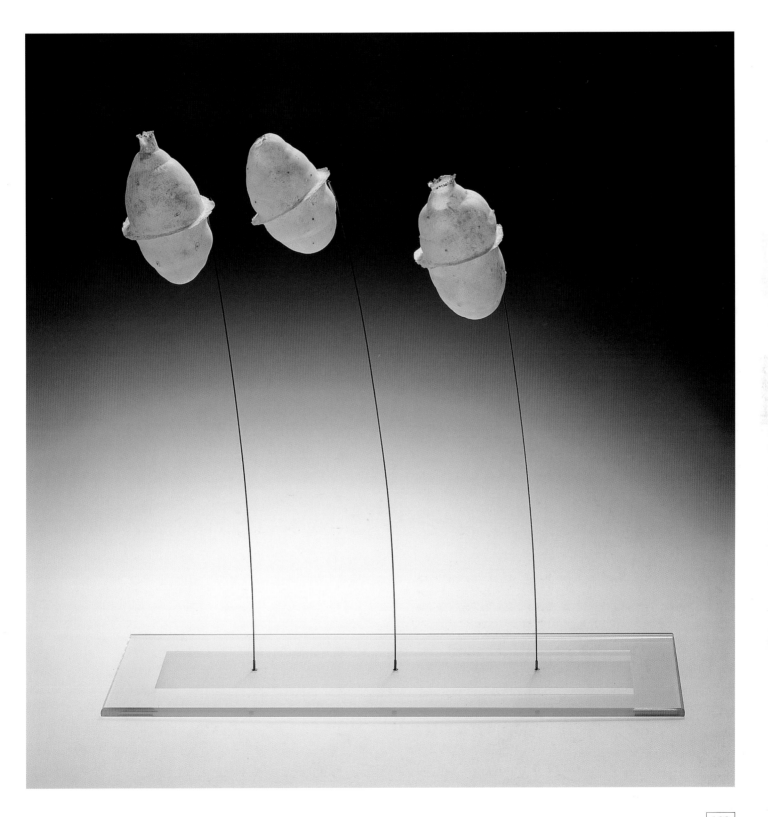

SECTION FOUR : NATURE AND SPIRIT

Kei Ito
Metal Coat, 1995
Metal-coated paper
140 × 130 cm

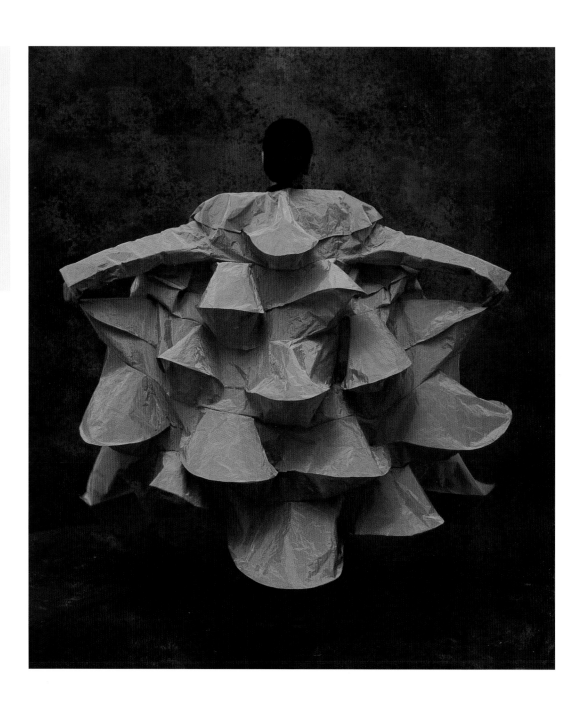

'Most of my work with paper has been in relationship to costume design for dancers. Above all else it is the combined qualities of lightness and fluidity that attract me, alongside new possibilities of folding. Somehow the body articulates itself with different nuances when clad in paper.'
Kei Ito

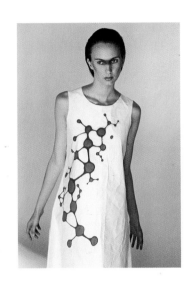

Kei Ito
Paper Dress, 1998
Paper (Tyvek)
140 × 70 cm
Make-up by Nadirav Persaud

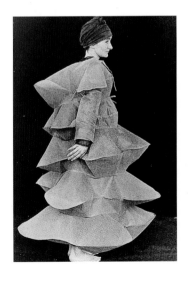

Kei Ito
Paper Coat, 1996
Polyester wadding
140 × 120 cm

SECTION FOUR : NATURE AND SPIRIT

Kaarina Kaikkonen has built countless works and installations using both paper and found paper objects, including potato sacks and lavatory paper. Her work explores her personal experience of the human condition and the environment in which she finds herself.

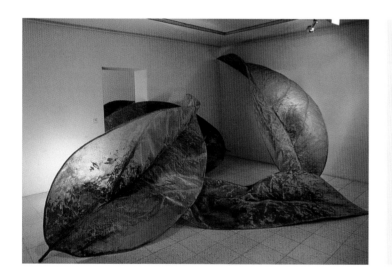

Kaarina Kaikkonen
And the Wind Blows Over You,
1992
Paper and fibreglass
400 × 400 × 400 cm

'Through my work I try to search for my constantly changing outline. I need to understand where the internal ends and the external begins.'
Kaarina Kaikkonen

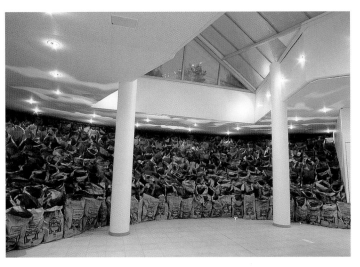

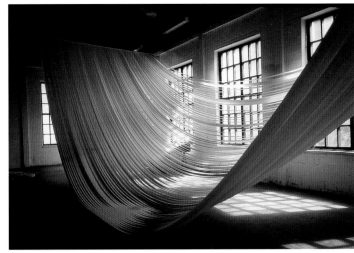

Kaarina Kaikkonen
Mouths open, 1990
potato sacks
Dimensions variable
Kuusankoski, Finnish Gallery
for Paper Art

Kaarina Kaikkonen
My Outline, 1997
1.5 km of lavatory paper

SECTION FOUR : NATURE AND SPIRIT

The installations of Kyoko Ibe, made
as public commissions for galleries
and for theatrical performances,
have an international, cosmopolitan
feel. Despite this, the performative
element and use of traditional *washi*
make these works identifiably
Japanese.

Kyoko Ibe
White Wind, 1992
Kozo paper, mirror and neon
light
300 × 180 × 180 cm

far right
Kyoko Ibe
White Wind, 1992 (detail)

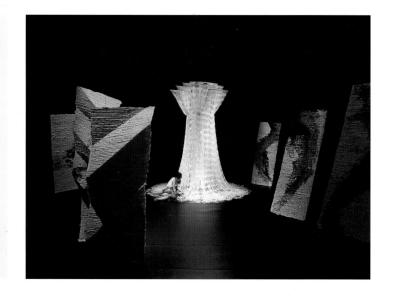

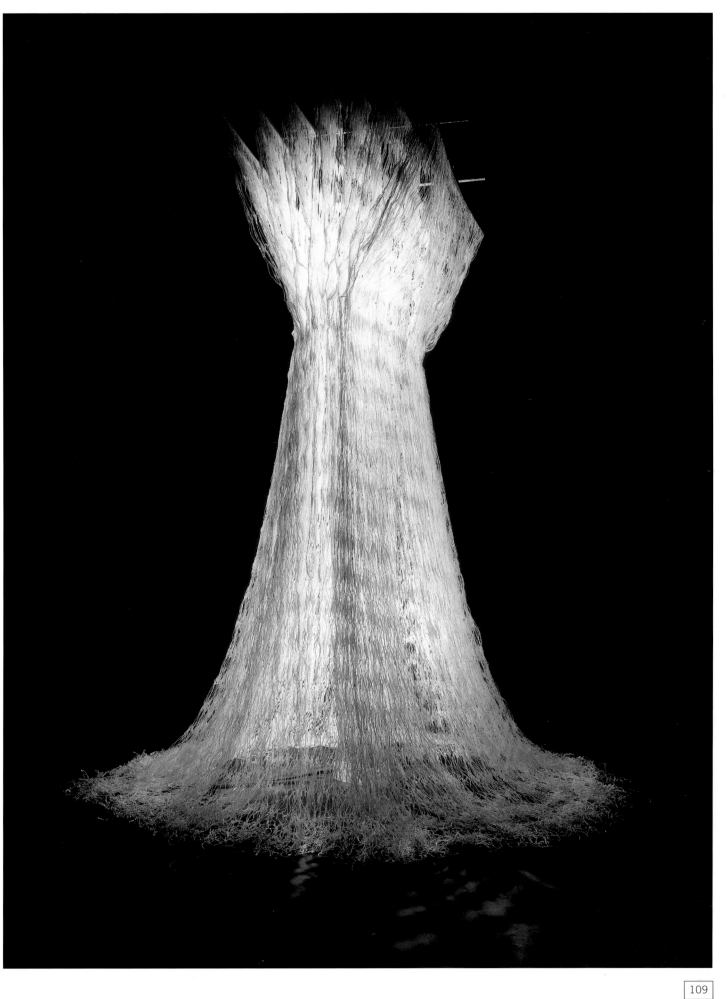

GLOSSARY

ABACA Also called Manila hemp, a plant (*Musa textilis*) related to the banana and primarily cultivated in the Philippines, as well as in Asia and South America, for rope, textiles and paper. The leaf stems provide exceptionally strong FIBRES that make a versatile, all-purpose, papermaking pulp.

ALKALI A caustic substance used in COOKING plant FIBRES to remove gums, waxes, starch and other non-CELLULOSE materials.

ALUM A complex salt (most commonly aluminium sulphate), added with ROSIN to the PULP as a sizing (see SIZE) agent. Usually makes paper acidic and is therefore best avoided unless neutralized.

AMATE (AMATL) A pounded mulberry-bark paper, similar to TAPA, originally made by the Aztecs using the inner bark of fig trees (*Ficus sp.*). *Amatl* is still made by the Otomi Indians of Southern Mexico.

BASE A term used in ORIGAMI to describe a simple, abstract, geometric folded shape that has the potential to be developed into a multitude of diverse designs. A base is identified by a well-known traditional model that can be made from it; for example, the fish base, the kite base, the waterbomb base and the bird base.

BAST FIBRE The inner bark of such plants as FLAX, HEMP, RAMIE, GAMPI, MITSUMATA and KOZO; separated from the outer bark and suitable for papermaking.

BEATER See HOLLANDER BEATING ENGINGE.

BEATING The process of cutting and bruising or roughening of FIBRES, which increases their surface area (see FIBRILLATION) and therefore their BONDING potential during the sheet-forming process.

BLEACHING A process used to purify and whiten PULP, usually done with chlorine compounds. Excessive bleaching may damage the FIBRES.

BONDING The inherent ability of CELLULOSE fibres to adhere to one another. FIBRILLATION, HYDRATION, pressing and drying are all factors in promoting bonding.

BUFFERING AGENT (ALKALINE RESERVE) An alkaline substance, usually CALCIUM CARBONATE or magnesium carbonate, that is added to the pulp to protect the finished paper from any acidity that may develop.

CALCIUM CARBONATE Used primarily to promote longevity in paper (see BUFFERING AGENT). In larger amounts it acts as a FILLER to retard shrinkage in paper casting, and in sheetforming to improve opacity and whiteness.

CALENDERING The process of pressing paper through a series of rollers (usually metal) to increase its surface smoothness.

CAST PAPER Three-dimensional paper pieces most commonly made by pouring or pressing pulp in or around a MOULD or form. The excess water is removed through sponging. Once the paper has dried, it is separated from its mould and can function independently as a relief or sculpture. Many innovative variations of this process have been developed.

CELLULOSE The main constituent of plant tissues, from which it must be separated before it can be used, providing the basic substance for paper manufacture.

CHAIN LINES The widely spaced lines visible in paper made in a LAID MOULD, created by the thin tying wire used to sew the laid wires to the cover of the mould.

CHINA CLAY (KAOLIN) A fine white powder that can be added to PULP as a FILLER or to give opacity to the finished sheet. It is especially useful in paper casting.

COCKLING The wavy or puckered edges of a handmade sheet, usually due to uneven drying.

COOKING The treatment of raw FIBRES to promote separation, remove contaminents, and dissolve unwanted plant material (see also LIGNIN), usually in an alkaline solution.

COTTON One of the purest forms of CELLULOSE and the primary FIBRE in Western hand papermaking. Both the shorter fibres attached to the seeds of the cotton plant (*Gossypium sp.*) and longer fibres used in the textile industry to make cloth (see COTTON-RAG PULP) can be used.

COTTON LINTERS PULP The PULP produced from the short seed hairs of the cotton plant, which has been COOKED, BEATEN and made into compressed sheets.

COTTON-RAG PULP A PULP made from the long staple cotton that is first spun, then woven into cloth.

COUCHING The action of transferring a newly formed paper from the MOULD on to a dampened FELT blanket so that water can be pressed out. The coucher is the person who carries out this operation.

CRUMPLING An ORIGAMI folding technique in which the paper is crumpled while wet (see WET-PAPER FOLDING).

DAPHNE The 'Paper Plant of Nepal', *Daphne bholua*, is in the Thymelaeaceae family of plants, as are MITSUMATA and GAMPI. It produces an extremely strong paper.

DECKLE A removable wooden frame that fits over the MOULD and helps retain the PULP on the mould surface during the papermaking process.

DECKLE EDGE The uneven, slightly wavy edges of a sheet of handmade paper, where the PULP has thinned towards the edges of the MOULD, an effect found only in handmade paper.

DYES Water-soluble colouring agents that usually penetrate and become attached to the FIBRES. Types of dyes include: direct dyes, organic dyes derived from coal-tars; fibre-reactive dyes, which form a chemical bond with the fibres; and natural dyes, such as indigo and madder. Dyes that require an acid MORDANT to set or fix them to the fibres should be used with caution.

EMBEDDING Incorporating materials in a sheet of paper, so that the FIBRES hold the embedded material in place.

EMBOSSING The process of creating a raised or depressed surface design in a sheet of paper, resulting in a relief image on the finished sheet.

FELT An absorbent, woven material, usually of wool, on to which a newly formed paper is COUCHED and that supports the wet sheet during the pressing process. In Japanese papermaking no felts are used.

FIBRES CELLULOSE-based material derived from plant matter that forms, when mixed with water, the basis of a sheet of paper. Papermaking fibres are hollow, tube-like structures with walls made up of slender, thread-like fibrils.

FIBRILLATION Shredding and bruising of fibre walls during the BEATING process so that tiny thread-like hairs (or fibrils) are unravelled from the surface of the fibre.

FILLER A material, usually a mineral such as CHINA CLAY, CALCIUM CARBONATE or titanium dioxide, added to the FIBRE during the BEATING stage to fill in the pores, thus changing the weight and surface appearance of the finished sheet.

FINISHING Practices of drying, sizing (see SIZE) and looking over sheets of paper after the making process.

FLAX A BAST FIBRE from the plant *Linum usitatissimum*, from which linen cloth is produced. PULP from flax fibre or linen rags can be used to make exceptionally strong, translucent paper.

FORMATION Refers to the FIBRE distribution throughout a sheet of paper, seen when holding it up to the light, and is related to the BEATING of the FIBRE and the action of distributing the PULP on the mould.

FORMATION AID Used in Japanese papermaking to separate long-fibred PULPS and control drainage during sheet forming (see NERI). As a deflocculant, it is also useful in Western papermaking techniques, for example, pulp painting.

FOURDRINIER MACHINE The name applied to the normal type of papermaking machine, after the brothers who financed its early development.

FURNISH The combination of ingredients in the BEATER, which, when added together, give a specific type of paper.

GAMPI A BAST FIBRE (*Wikstoemia diplomopha*) of the Thymelaeaceae or Daphne family, used for Japanese handmade paper. It is a slow-growing plant and difficult to cultivate. Produces a crisp, rattly paper. See also KOZO and MITSUMATA.

GELATINE A type of SIZE obtained from animal tissues or bone, applied to the surface of paper to make it impervious to water.

GLAZING The process used to impart a smooth surface to a sheet of paper through pressing or friction, often by running dried sheets through steel rollers or between polished zinc plates. See also CALENDERING.

GRAIN The alignment of FIBRES in a sheet of paper caused by their directional flow on the mould surface during sheet formation.

HALF-STUFF Commercially prepared, partially broken or beaten fibre stock. Further BEATING is necessary before it can be used for papermaking.

HEMP A BAST FIBRE plant (*Cannabis sativa*) of high CELLULOSE content and, like ABACA and FLAX, one of the longest, strongest FIBRES available for papermaking. It is believed to be the original fibre used in China two thousand years ago.

HOLLANDER BEATING ENGINE A device invented in Holland in the middle of the seventeenth century that superseded the STAMPER.

HYDRATION Occurs during the BEATING process as the bruised and roughened FIBRES begin to absorb water. Hydration increases BONDING strength and reduces opacity because of the water held in the FIBRE.

KAMIKO Japanese nonwoven paper cloth.

KAOLIN See CHINA CLAY.

KENAF A BAST FIBRE from the plant *Hibiscus cannabinus*. As in the case of most raw FIBRES, it should be COOKED with LYE first, washed and then beaten in a HOLLANDER BEATING MACHINE.

KOZO Japan's most widely used BAST FIBRE (*Broussonetia papyrifera*) is a fast-growing and easily cultivated deciduous shrub of the Moraceae or mulberry family. It has been a source of FIBRE since the early days of papermaking. In general, the long kozo fibres make a strong and dimensionally stable paper.

LAID LINES The close, light lines in laid paper. It is customary for the laid lines to run across the page's width, and CHAIN (linking) LINES from head to foot.

LAID MOULD A mould the cover of which is made of closely spaced parallel wires (LAID LINES), held in place by more widely spaced wires (CHAIN LINES) worked in the perpendicular direction.

LAMINATING Combining two or more layers of paper by COUCHING one newly formed sheet of paper on top of another to create a single sheet.

LAYER The person who separates the sheets of handmade paper from the FELTS after pressing.

LIGNIN A component of plants that rejects water and tends to decrease FIBRE-to-fibre bonding in paper. It must be removed before the papermaking process begins (see also COOKING) to avoid degradation of the resulting paper.

LYE A strong alkaline solution used to COOK FIBRES.

METHYLCELLULOSE A specially formulated powder that can be used as an adhesive, as a surface SIZE, or to promote FIBRE-to-fibre BONDING and strengthen paper castings.

MITSUMATA One of the three plants (also GAMPI and KOZO) used for Japanese papermaking. Mitsumata (*Edgeworthia papyrifera*) is a member of the Thymelaeaceae or DAPHNE family. The FIBRE is soft, absorbent and slightly lustrous. The paper has a smooth surface that is very good for printing.

MORDANT In dyeing, a chemical substance used to fix colours to FIBRES.

MOULD The basic tool of hand papermaking, consisting of a rectangular wooden frame covered with a fixed mesh surface and removable DECKLE. Varying designs exist in different countries.

NAGASHI-ZUKI Japanese term for the hand-papermaking process that uses lightly beaten BAST FIBRES and NERI.

NERI A viscous liquid that is the key to Japanese papermaking, usually obtained from the root of the tororo-aoi plant, a member of the hibiscus family. This liquid changes the viscosity of the water, thus keeping the FIBRES in suspension and slowing the rate of drainage. This enables the papermaker to move the fibres repeatedly over the surface of the screen to build up the thickness of the *WASHI* layer by layer.

ORIGAMI The Japanese art of paper folding (*ori* means 'to fold' and gami means '*paper*'). In its purest form the paper is only folded, not cut, glued or decorated.

PACK A pile of damp sheets, separated from the FELT after the first pressing, or a small stack of paper ready for glazing.

PAPIER MÂCHÉ moulded paper PULP used to produce objects in many different cultures.

PAPYRUS A LAMINATED writing surface made from the sliced inner pith of the papyrus plant.

pH A term used to denote the degree of acidity or alkalinity of a substance.

PIGMENT Colouring matter in the form of insoluble, finely ground particles, which have no affinity to the material they are colouring and must be used with a RETENTION AGENT to ensure maximum colour intensity and proper adhesion to the PULP.

POST A term applied to a pile of newly made paper COUCHED with alternate felts and ready for pressing.

PULP A general term used to describe the aqueous stuff containing disintegrated fibrous material from which paper is made.

RAGS The original material from which paper was made; now rarely used except for the highest quality papers.

RAMIE A BAST FIBRE plant in the nettle family, native to South-East Asia.

RETENTION AGENT A substance formulated to aid the binding of PIGMENTS, DYES and other additives to papermaking fibres.

RETTING The preliminary separation of plant FIBRES, such as FLAX, by soaking the hard stems in water; they can then be broken to leave the fibres. Also the traditional method of softening or loosening cloth fibres prior to BEATING by heating up piles of wet RAGS so they rot and become easier to beat.

RIBS The thin wooden bars that support the wire cover of a MOULD. They usually run across the narrowest part and in a LAID MOULD support the CHAIN LINES.

RICE PAPER The paper-like material made by cutting and pressing the pith of the rice-paper plant (*Tetrapanax papyriferus*).

ROSIN A sizing agent derived from the distillation of turpentine or from the treated gum-pine tree. It is acidic in nature and detrimental to the permanence of paper. It requires the use of ALUM for precipitation on to the FIBRES.

SCENIC ROUTE The most beautiful folding sequence to achieve an ORIGAMI model. This is rarely the most direct route.

SHAKE The term applied to the sideways movement of the MOULD during sheet forming to interlock the fibres while they are still suspended in the PULP.

SHIFU Japanese woven-paper cloth.

SISAL From the plant *Agave sisalana*, sisal is a long-fibred PULP similar to ABACA.

SIZE A substance added during BEATING or after drying to make paper more water-resistant, to varying degrees, so that ink or paint does not run or feather. Originally a solution of GELATINE, gum or starch, now various chemical agents.

SODA ASH An alkaline substance (sodium carbonate) used in the COOKING of BAST or native plant FIBRES. It is strong enough to dissolve the non-CELLULOSE parts of the plant, yet will not weaken the finished paper.

SPUR A group of sheets dried naturally together.

STAMPER An early device powered by wind, water or an animal, consisting of hammers falling into a mortar and used for reducing rags and other raw materials to a PULP. Largely replaced by the HOLLANDER BEATING MACHINE.

STUFF Paper stock or PULP ready for making paper.

SUGETA The Japanese papermaking mould, comprising the *su* (removable, flexible screen) and *keta* (hinged wooden frame).

TAMEZUKI The Japanese term for Western sheet forming.

TAPA A Polynesian pounded-bark paper or cloth, usually made from the inner bark of the paper mulberry.

VACUUM FORMING A process for forming flat and low-relief paper pieces.

VACUUM TABLE A system of forming paper that uses a vacuum process to compress the PULP, usually comprising a perforated table connected to a vacuum chamber.

VAT A tank that contains the PULP into which the MOULD is dipped to make sheets of paper.

VATMAN The person who forms the sheet of paper by dipping the MOULD into the VAT and lifting it out.

WATERLEAF A term used to describe paper that contains no SIZING, and is therefore generally very absorbent.

WASHI The Japanese term for handmade papers traditionally produced in that country.

WATERMARK (WIREMARK) A darker or lighter area in a sheet of paper that becomes visible when the sheet is held up to the light. Usually created by attaching a fine wire design to the mould surface.

WET-PAPER FOLDING An ORIGAMI folding technique in which the paper is moulded into shape while wet with a series of softly made creases, which stay in position when the paper is dry.

WOVE MOULD See WOVE PAPER.

WOVE PAPER Paper made on a WOVE MOULD, where the covering screen is made from a fine woven mesh. Wove paper is smoother than laid paper, which has a ribbed appearance caused by the parallel LAID LINES running across the width of the MOULD.

There follows an international listing of principal papermaking contacts, grouped alphabetically by country. This list has been compiled for students and papermaking enthusiasts who wish to pursue the craft and explore further opportunities for research and practice. It is not a definitive listing but simply a starting point that identifies a range of different types of organizations from which information and teaching can be obtained.

It includes many well-known and experienced papermakers who share their knowledge and expertise with a wide audience. (It does not include specialist paper suppliers or manufacturers.) Many sources are online or about to join the Internet, and a search engine is a good starting point. For example, <www.paperjargon.com> is a site currently under construction that aims to provide a dictionary for the paper arts (papermaking, book arts, origami, calligraphy, quilling, decoupage), and a comprehensive listing of origami websites and other on-line origami information can be found at <www.origami.vancouver.bc.ca>.

Please bear in mind that this is not an exhaustive list, and addresses soon become out of date. If you would like to be included in future listings, write to Sophie Dawson c/o the Crafts Council, 44a Pentonville Road, Islington, London N1 9BY.

Many papermakers and artists also run papermaking and book arts courses and workshops in institutions, universities, colleges, arts and crafts centres, private studios, adult education centres, printmaking studios, and museums. A useful source of information is magazines such as *Crafts Magazine* (UK), *Printmaking Today* (UK), *Hand Papermaking Magazine* (USA), *Fiberarts* (USA) and *American Craft Magazine* (USA).

Paper travellers will find that many papermaking tours and trips are organized around the world to visit known (and unknown) papermaking facilities, villages or areas. Elaine Koretsky (USA), who has most recently led trips to China, Thailand and Burma, and Asao Shimura (Philippines) are especially well known for this. Note also that many paper groups, such as IAPMA (International Association of Hand Papermakers and Paper Artists, Germany) and FDHPM (the Friends of the Dard Hunter Paper Museum, USA), organize paper conferences that cover a wide range of papermaking practices. In addition, there are an increasing number of opportunities for viewing paper as a medium of expression, from established exhibitions such as the International Biennale of Paper Art held at the Leopold-Hoesch-Museum, Düren, Germany, to the more recent Holland Paper Biennial at the Museum Rijswijk, The Netherlands.

2001 is the year of a UK festival entitled *Japan 2001*. Supported by the Japanese and UK governments, the festival is intended to generate interest in all aspects of Japanese life. Several paper-related exhibitions are being held during *Japan 2001*, and these are included in the section on the UK, below.

Different services are identified by key letters:

A = Paper association/society

H = Hand papermaker

An individual, or small group of individuals, involved in making standard sheets by hand; may include other activities such as tuition, special makings, artist collaborations, papermaking supplies and so on. Many hand papermakers have travelled widely to research their craft and teach artistic applications of Oriental and Western hand papermaking at universities and craft schools nationwide. Many are faculty members at their local college of art and design, teaching sculpture, printmaking (including photographic processes), book arts, papermaking, and two- and three-dimensional foundation. It is worth contacting your local colleges for details of courses.

I = Information centre

Mu = Museum of papermaking

Many museums and papermills will offer demonstrations of techniques and arrange visits to nearby papermaking facilities.

W = Workshops/studios

These are too numerous to list comprehensively; they present various opportunities for professional development. Many of the studios are set up in collaboration with artists who wish to produce art works in paper; some will undertake special makes; many sell papermaking supplies; others teach the craft of papermaking and offer facilities for further study; and a few have galleries attached for exhibiting paper-related projects.

U = Universities and colleges of art and design offering papermaking and book-arts programmes

ARGENTINA

H *Molino del Manzano*
(Vicky and Pablo Sigwald)
Fondo de la Legua
1642 San Isidro
Buenos Aires
T: +54 (011) 763 8682

AUSTRALIA

I *Christine Ballinger*
T: +61 (07) 5445 7317
F: +61 (07) 5478 6109
E: flaxtonmill@sun.big.net.au
For information on *New Possibilities for Paper*, a conference to be held from 13 July to 15 July 2001.

A *Papermakers Guild of Western Australia*
(Gladys Dove)
37 Denny Way
Alfred Cove
WA 6154
T: +61 (08) 9330 4102
Monthly newsletter listing classes, workshops, paper samples and so on. The guild frequently plays host to papermakers from other parts of Australia, the USA, New Zealand and Japan.

A *Papermakers of Australia*
(Penny Carey-Wells)
33 Nicholas Drive
Kingston
Tasmania 7050
T: +61 (03) 6229 3568
F: +61 (03) 6229 1893
E: pcareywe@tassie.net.au

A *Papermakers of New South Wales*
(Jean Kropper)
PO Box 1292
Lane Cove
Sydney
NSW 2066

A *Papermakers of Victoria*
Gail Stiffe (President)
11 Keltie Street
Burwood
Victoria 3125
T: +61 (03) 9889 7302
E: Stiffe@BlueP.com
W: www.home.vicnet.au/-paper.vic/
Formed in 1989 to provide support for hand papermakers through the exchange of ideas and information, discussion and demonstrations. The society aims to promote the craft to a wider

audience through a regular programme of exhibitions and workshops. Members include bookbinders, printmakers, collage and fibre artists, calligraphers, and paper conservators. Publishes a newsletter, *The Deckle Edge*.

H I *Primrose Paperworks Co-operative Ltd*
PO Box 152
Matora Lane
Cremorne (off Young Street)
Sydney
NSW 2090
T: +61 (02) 909 1277
W: www.aimit.com.au/primrose/workshop/htm
Based in Sydney, this non-profit-making co-operative began in 1990, following the earlier success of the First International Paper Conference in Australia in 1987. The centre is unique in Australia in its dedication to the paper arts, and offers a wide range of workshops: basic papermaking, plant fibre and oriental papermaking, pulp painting and paper casting, bookbinding, calligraphy, printmaking and photography.

AUSTRIA

Mu *Museum of Papermaking Laakirchen-Steyermühl*
Museum Plazt 1
A-4662 Steyermühl
T: +43 7613 3951
F: +43 7613 8834
W: www.members.vienna.at/diffr/ papiermachermuseum/
A new museum that opened in June 1999.

W *Papier Wespe*
(Beatrix Mapalagama)
Aegidigasse 28/25
1060 Vienna
T/F: +43 1 715 1891
E: papierwespe@hochstrasse.at
W: www.hochstrasser.at/papierwespe
Papier Wespe is a small centre for hand papermaking and paper art, combining contemporary and traditional hand-crafted methods. It also includes workshops and artist collaborations.

BELGIUM

W *Jean Decoster*
Hannuitsesteenweg 114
3300 Tienen
T: +32 16 81 14 86
Write for details of the project *Simply a Sheet of Paper* (1988), a travelling exhibition and symposium in Belgium and The Netherlands.

I Mu *Musée National du Papier*
Maison Cavens
Place de Rome 11
B-4960 Malmedy
T: +32 80 33 7058
F: +32 80 33 9232
The museum has sections on the history of papermaking, demonstrations of papermaking by hand, and artefacts and machinery relating to papermaking.

CANADA

W I *Atelier Papyrus Inc.*
523 rue St-Paul
Trois Rivières
Québec G9A 1H7
T: +1 (819) 372 0814
The Atelier Papyrus was established in 1984 as a non-profit-making organization dedicated to the promotion of hand papermaking, and provides papermaking services and facilities. It runs workshops, events, conferences and exhibitions, and produces a range of specialty handmade papers, together with some supplies for hand papermaking.

W *The Banff Centre for the Arts*
(Wendy Tokaryk, Media and Visual Arts Department)
Box 1020
Station 28
107 Tunnel Mountain Drive
Banff
Alberta T0L 0C0
T: +1 (403) 762 6100
F: +1 (403) 762 6444
E: arts_info@banffcentre.ab.ca / wendy_tookaryk@banffcentre.ab.ca
W: www.banffcentre.ab.ca/CFA
Although the centre has no dedicated papermaking programme, papermaking workshops are intetgrated into regular creative residencies in photography, printmaking and papermaking. It has first-rate facilities and a wide range of creative, professional and research opportunities.

H *Kathryn Blake*
Bullfield Farm
104 East Road
Ketch Harbour
Nova Scotia B3V 1K5
T: +1 (903) 866 2472
E: paper@navnet.net

H W *Cedar Ridge Handmade Paper*
(Barbara McQueen)
126 Woodbine Lane
Upper Kingsclear
New Brunswick E3E 1SW
T: +1 (506) 363 5583
E: rmcqueen@nbnet.nb.ca

H W *Flax Paper Works*
(Helmut Becker)
10835 Gold Creek Drive RR4
Komoka
Ontario N0L 1R0
T/F: +1 (519) 666 0624
E: hbecker@julian.uwo.ca
Helmut Becker has been making paper and paper art for more than three decades, and has spent most of that time studying the history of, growing, and working with flax.

W I *Kakali Handmade Papers Inc.*
1249 Cartwright Street
Granville Island
Vancouver
British Columbia V6H 3R7
T: +1 (604) 682 5274
This organization functions principally as a paper institute and offers workshops in papermaking and book arts.

W *The Paper Trail*
1546 Chatelain Avenue
Ottawa
Ontario K1Z 8B5
T: +1 (613) 728 4669
F: +1 (613) 728 7796
Located in an old warehouse, the mill offers workshops in all aspects of papermaking, book arts and artists' collaborations. Includes a special projects room and paper art gallery.

H *Papeterie Saint-Armand*
(David Carruthers, Director)
3700 rue St-Patrick
Montréal
Québec H4E 1A2
T/F: +1 (514) 931 8338
W: www.aquarelle.ca/avril98/papermill/html
The mill was founded in Montréal in 1979 to produce handmade papers in the traditional style but with a 'dash of modern technology'.

H Mu *Papeterie Saint-Gilles*
(Hélèn Desgagnes)
304 rue Felix Antoine Savard
Charlevoix
Québec G0A 3Y0
T/F: +1 (418) 635 2430
T/F: +1 (418) 635 2430

COSTA RICA

H I *Centro de Investigaciones en Fibras y Papel*
(Lil Mena)
Apartado 103
1002 San José
The Centre for Fibres and Paper Research held its first symposium on handmade paper in 1991. It operates a papermill, a documentation centre, and a studio for book arts and oriental and decorative papermaking.

CZECH REPUBLIC

Mu *Paper Museum Velké Losiny*
Rucní Papirna
788 15 Velké Losiny
Sumperk
T: +42 (0) 649 248 191
F: +42 (0) 649 248 418
E: rucni.papir@olpa.cz
W: www.morpa.cz/losiny/13en.htm
Historic papermill said to be the oldest functioning manufacturing plant in Central Europe. Paper is still made by hand using original formulas and processes.

DENMARK

W I *Stryno Papir Atelier*
(Anne Vilsbøll)
Fredensgade 4
Stryno
DK-5900 Rudkøbing
T: +45 62 515002
F: +45 62 515012
E: vils@post7.tele.dk
One of the first hand papermaking studios in
Denmark, established in 1983. Group visits,
workshops and studio rental with assistance.

EGYPT

H Mu *Papyrus Institute*
3 Nile Avenue
PO Box 45
Orman
Giza
Cairo
T: +20 2 989 476

FINLAND

W I *Finnish Paper Art Centre*
(Väiski Putkonen)
Kaivokatu 9A4
FI-06100 Porvoo
T/F: +358 19 583 522
E: vaiski@hotmail.com
This organization runs various paper workshops
and educational programmes in Finnish art
institutues.

FRANCE

Mu *Atelier-Musée du Papier*
(Denis Peaucelle, Director)
134 rue de Bordeaux
F-16000 Angoulème
T: +33 5 4592 7343
F: +33 5 4592 1599

H *Moulin du Fleurac*
F-16440 Nersac
T: +33 5 4591 5069

H *Moulin de Larroque*
(Georges Duchêne)
Couze
F-24150 Lalinde
T: +33 5 5361 0175

Mu *Moulin à Papier de Brousses*
(Andre Duraud, Director)
F-11390 Brousses et Villaret
T/F: +33 4 6826 2743
Historic papermill in Languedoc, founded in 1674,
which continues its production of handmade paper.

H Mu *Moulins de Pen-Mur*
B.P. 28
F-56190 Muzillac
T: +33 2 9741 4379
F: +33 2 9745 6078

H Mu *Moulin à Papier Richard de Bas*
(Patrice Peraudeau, Director)
F-63600 Ambert
Puy de Dôme
T: +33 4 7382 0311
F: +33 4 7382 2541
E: rbd@wanadoo.fr
The oldest French hand papermill and foremost
paper museum in France.

H *Moulin Vallis Clausa S.A.*
(Micol Pierre)
Chemin de la Fontaine
F-84800 Fontaine de Vaucluse
T: +33 4 9020 3414
F: +33 4 9020 2340

H *Moulin du Verger du Pumoyen*
(Jaques Bréjoux, Director)
F-16400 La Couronne
T: +33 5 4561 1048
F: +33 5 4561 6808

A *Mouvement Français de Pliage des Papiers*
56 rue Coriolis
75012 Paris
T: +33 143 430 169

Mu *Musée des Papeteries Canson et Montgolfier*
BP 139
F-07104 Annonay
T: +33 (4) 7569 8800
F: +33 (4) 7569 8888
Hosted the 1994 IPH Congress.

GERMANY

W *Ebrantshauser Papierwerkstatt*
(Joachim Tschacher)
Ebrantshausen 2 1/2
D-84048 Mainburg
T: +49 8751 9990
F: +49 8751 9944
E: papier@tschacher.de

H W *Eifeltor Mühle*
(John Gerard)
Auf dem Essig 3
D-53359 Rheinbach-Hilberath
T: +49 2226 2102
F: +49 2226 913 437
E: gerard@eifeltor-muehle.de
W: www.gerard@eifeltor-muehle.de
One of the best, most fully equipped facilities in
Europe working on the professional level in the
paper medium. Courses offered, usually weekend
seminars (for example, colouring pulp, flax fibre,
pulp painting). The workshop is based on three
principles: consultation and collaborative projects
with artists by appointment; a small sheet
production facility; and experimental work with
paper. John Gerard teaches papermaking and book
arts at various academic institutions within
Germany.

A *International Association of Hand Papermakers
and Paper Artists
(IAPMA)*
Eva Maria Juras (Secretary)
Tulpenstrasse 20
D-51427 Bergisch Gladbach
T: +49 (0) 2204 678 72
F: +49 (0) 2204 961 428
E: evajuras@aol.com
W: www.crafts.dk/org/iapma
An international organization founded in 1986 to
facilitate and encourage the exchange of ideas and
information about hand papermaking. Its new site
from summer 2001 will be <www.iapma.net>. See
POLAND, *Museum Papiernictwa*, for details on the
IAPMA Congress 2001, and **USA**, *Columbia College
Chicago Centre for Book and Paper Arts*, for details
on the IAPMA Congress 2002.

A *International Paper Historians*
(Ludwig Ritterpusch)
Wahrdaer Strasse 135
D-35041 Marburg/Lahn
T: +49 (0) 64 21 817 58
W: www.paperhistory.org

I *Kristine Kautz*
(Fascination Paper 8)
Dorfstrasse 25
D-17495 Gladrow
T/F: +49 3 83 556 1220
Write for details of the 8th International Workshop
Fascination Paper, which has *Water – Marks* as its
theme. The workshop takes place from 26 August
to 8 September 2001 in Wrangelsburg,
Mecklenburg-Vorpommern, Germany.

H W Mu *Museum Papiermühle Homberg*
(Johannes Follmer)
Gartenstrasse 7
97855 Markt Triefenstein
Homberg am Main
T/F: +49 (0) 9395 99 222
E: papiermuehle-homburg@t-online.de
W: www.papiermuehle-homburg.de
After extensive renovation, this Homberg papermill
and museum opened in 1997. Situated in the
original Bavarian papermill on the River Main,
which was built in 1807 and operated until 1975, it
provides demonstrations on renovated machines in
an original setting. Also hand papermaking and
workshops, lectures and so on.

A *Origami Deutschland EV*
Postfach 1630
85316 Friesling

H Mu *Papier Museum Düren*
(Dr Dorothea Eimert, Director)
Leopold-Hoesch-Museum
Hoeschplatz 1
D-5160 Düren
T: +49 (0) 242 252 559
F: +49 (0) 242 116 9680
E: papiermuseum@csi.com

Small working hand papermill and museum. The International Biennale of Paper Art has been held here since the first exhibition in 1986. The museum has a commitment to exhibitions of papermaking and book arts.

W *Pflanze-faser-papier*
(Helmut Frerick)
Artishof
Kirchstrasse 34
Berg
D-52385 Nideggen
T: +49 (0) 2427.1695
F: +49 (0) 2527.900720
E: pfpfrerick@aol.com
Well-equipped hand-papermaking studio with workshop schedule throughout the year (also at the Font du Ciel studio in Charrus, France). Artist-in-residence programme and studio rental. Hosted post-IAPMA Congress workshop, with Catherine Nash (USA), in 2000.

H *Wekstatt fur Papier*
(Gangolf Ulbricht)
Mariannenplatz 2
10997 Berlin
T: +49 (0) 30 615 8155
F: +49 (0) 30 615 7315
E: gangolf.ulbricht@p-soft.de
Hand-papermaking studio for custom makings, as well as standard manufacture and artist collaborations. No visitors. One-year minimum apprenticeship possible. Occasional workshops. Gangolf Ulbricht teaches regularly at the Berlin Art Academy and the Art Academy in Munich.

GREECE

A *Aeora*
(Maria Malakos)
27 Veikou Str.
11742 Athens
T/F: +30 1 9227 621
E: aeora@otenet.gr
A group dedicated to the study of pre-industrial techniques, currently organizing a permanent exhibition of paper history and a papermaking workshop.

HUNGARY

H Mu *Papiripari Vallalat*
Diósgyöri Papirgyára
Hegalja u. 203/I
Miskolc 3510

I *Society of Hungarian Paper Arts*
(Margit Gerle)
6000 Kecskemét
Budaihegyut 165
Társáság
T: +36 76 325 742

INDIA

I *Handmade Paper Institute*
K.B. Joshi Road
Shivajinagar
Pune 411 005
T: +91 20 56383
F: +91 20 444253

H I *Kalamkush Handmade Paper Centre*
Gandhi Ashram
Ahmedabad 380 027
T: +91 79 755 9831
 +91 79 755 9832
F: +91 79 755 9833

I *Kalpana Handmade Paper Industries*
Bawri Ka Bass
Jain Hostel Road
Namdeo Colony
Sanganer
Jaipur 303 902
T/F: +91 141 732 115
E: saini@kalpanahandmadepaper.com

H I *Kumarappa National Handmade Paper Institute*
Ramsingh Pura
Sikarpura Road
Sanganer
Jaipur 303 902
T/F: +91 141 55 2015

H *Sri Aurobindo Handmade Paper*
(Kartikeya Anurakta, Manager)
50 Patel Salai
Pondicherry 605 001
T/F: +91 413 334763
 +91 413 338132
E: sahmp@vsnl.com
Established in 1959 as part of a scheme of assistance presented by the Khadi and Village Industries Commission to encourage the development of small-scale industries in the rural areas of India. Artist collaborations.

ISRAEL

I *Israeli Origami Center*
Bialik 77
Ramat Gan 52346

W *Laura Behar*
12 Derech Meitar
PO Box 723
85025 Meitar
T: +972 8 651 7729
E: beharl@netvision.il
A student of the late Joyce Schmidt, who founded the Beer-Sheeva papermill in Israel, Behar teaches workshops to artists, art teachers and children, using fibrous desert plants found in the surrounding area.

H W *Natan Kaaren*
79351 Kibbutz Sde Yoav
T: +972 7 672 1291
F: +972 7 672 1111
E: anan98@inter.net.il
Papermaker offering workshops, artist collaborations and tools for papermaking.

W *Ora Lahaz-Chaaltiel*
Atelier 65
Artists Village
Ein-Hod 30 890
T: +972 4 984 2018
F: +972 4 984 1071

H W *Tut Neyar*
Izhar Neumann
39 Hameyasdim Street
Zichron Ya'akov
T/F: +972 6 639 631
E: tutneyar@bezequint.net

ITALY

H Mu *Cartiere Enrico Magnani SPA*
Localita Calamari
I-51017 Pescia
T: +39 (0) 572 405486
F: +39 (0) 572 405523
Sadly, this historic papermill is no longer in production, but it is possible to view it by appointment. The city of Pescia has, however, set up a conference centre, the Centro di Documentazione sulla Lavorazione della Carta, where one can survey a developing exhibition of the history of the mill, and techniques for the production of handmade paper.

A *Centro Diffusione Origami*
PO Box 42
21040 Caronna
H W Cusignana Mill
(Stephan Koehler)
Villa Agostini
Via Colombere 133
Cusignana Giavera
I-31040 Treviso
T: +39 (0) 422 770005
F: +39 (0) 422 770684
Mill, workshops and briefings in traditional Japanese papermaking; includes a workshop, La Scuola di Carta. European partner of The Craftslink, Japan.

H Mu *La Fondazione Museo della Carta*
Valle dei Mulini
Amalfi
La Fondazione opened in 1993 in one of the oldest surviving mills in Amalfi, dating from the fourteenth century. Historic papermaking equipment on display, as well as a collection of historic papers, books and photographs.

H W *Paola Lucchesi*
Maiz Paper Studio
Via di Falle
I-50061 Compiobbi Fl
T/F: +39 (0) 55 659 4065
Paola Lucchesi's background is in paper
restoration and conservation. She now creates
experimental handmade paper, using local plant
and recycled fibres, and, together with Catherine
Nash (USA), hosted a collaborative workshop for
IAPMA members during the IAPMA Congress in
Italy in 2000.

H W *Roberto Mannino*
Via Flaminia 466
I-00191 Rome
T/F: +39 (0) 63 333 656
Artist's studio with a good variety of quality
equipment and facilities. Workshops offered, also
internship programme.

H Mu *Museo della Carta e della Filigrana*
Largo Fratelli Spacca
60044 Fabriano
T: +39 (0)732 709 297 22334
E: info@museodellacarta.com
W: www.museodellacarta.com
Fabriano has a very long history of papermaking in
the town and region, and boasts the largest paper
museum in Italy.

JAPAN

Mu *Awagami Factory*
The Hall of Japanese Handmade Paper
c/o Fuji Paper Mills Co-operative
(see below)

H W *The Craftslink*
2485 Yatsubo Warabi
Mino City
Gifu Pref. 501-37
T: +81 (0) 575 34 8335
F: +81 (0) 575 46 2739
Partner of Cusignana Mill, Italy

H Mu *Fuji Paper Mills Co-operative*
The Hall of Japanese Handmade Paper
(Aya Fujimori)
136 Kawahigashi
Yamakawa-cho
Oe-gun
Tokushima Pref. 779-3401
T: +81 (0) 883 42 2035
F: +81 (0) 883 42 6085
E: aya@awagami.or.jp
W: www.emile.co.jp/awagami
A non-profit-making organization established to
preserve and broaden awareness of Japanese
handmade papers. This is done through
workshops, research, special events, exhibitions
and so on. Annual Papermaking Workshop each
summer.

H I *Fukui-Ken Papermakers Co-operative*
Otake 1-11
Imadate-cho
Imadate-gun
Fukui Pref.
T: +81 (0) 778 43 0875
F: +81 (0) 778 43 1142

Mu *Ino-Cho Paper Museum*
(Yoshinori Machida, Director)
110-1 Saiwai-cho
Ino-cho
Awa-Gun
Kochi Pref. 781-21
T: +81 (0) 888 93 0886
E: tosawasi@bronze.ocn.ne.jp
W: www.isei.or.jp/Paper_Museum
Established in 1985 with the aim not only of
conserving traditional Japanese papermaking
techniques in a town with a long history of
papermaking, but also of promoting contemporary
opportunities.

I *International Origami Center*
(Akira Yoshizawa)
PO Box 3
Ogikubo
Tokyo 167

I *The Japan Paper Academy*
Kyoto Chamber of Commerce and Industry Bld. 6F
Karasuma-dori
Ebisugawa-agaru
Nakagyo-ku
Kyoto 604
T/F: +81 (0) 75 313 29 39
Following the International Paper Conference held
in Kyoto in 1983, the Japan Paper Academy was
founded in 1988 as a group concerned exclusively
with paper culture. The JPA aims to promote and
develop the culture of paper through an exchange
of research and information, both internationally
and between members in Japan. Significant
activities during the 1990s included The
International Paper Symposium (1995), together
with the IAPMA Congress held in Kyoto (1995),
and *The All Japan Washi Exhibition: 'The Skill and
Soul of the Artisan'* (1996).

H A I *Kochi Hand Papermakers Co-operative
Association*
3-110 Asahi-machi
Kochi-shi 708
Kochi Pref.
T: +81 (0) 888 73 5898
F: +81 (0) 888 72 5218

H A I *Mino Handmade Washi Co-operative
Association*
777 Maeno
Mino
Gifu Pref.
T: +81 (0) 575 3482 78

Mu *National Paper Museum*
Kami No Hakibutukan
1-1-8 Horifune
Kita-ku
Tokyo
T: +81 (0) 3 3911 3545
F: +81 (0) 3 3911 3347

A *Nippon Origami Association*
2-046 Domir Gobancho
12-Gobancho
Chiyoda Ku
Tokyo 102-0076
T: +81 (0) 3 3262 4764

Mu *Nishinouchi Paper Museum*
90 Funyu
Yamagata-machi
Naka-gun
Ibaraki Pref. 319-31

I *Origami Tanteidan*
c/o Gallery Origami House
Asahi Mansion 2F
1-33-8-216 Hakusan
Bubkyo-Ku
Tokyo 112

Mu *Washi-No-Sato Museum*
11-12 Shinzaike
Imadate-cho
T: +81 (0) 77 842 0016

KOREA

Mu *Hansol Paper Museum*
180 2-ga
Pal-gok dong
Dok-jin gu
Chon-ju City
T: +82 (0) 652 210 8000
W: www.hansol.co.kr

I *Korea Jong le Jugpi Association*
Korea Paper Culture Centre
5th Floor
Jong le Nara B/D
62-35 Changchoong-Dong Ika
100-391 Choong-Ku
Seoul
T: +82 2 2264 4561
F: +82 2 2264 4565
E: jugpi@origami.or.kr

MEXICO

The Mbithe Ñañhu Cultural Center
(Benito Sósimo)
San Pablito
Pahuatlán
Puebla 73100
T: +52 766 34034
E:kering@ns.net
For information on *amate* papermaking in San
Pablito.

NEPAL

Nepal Crafts Collection (P) Ltd
GPO Box 981
Kathmandu
T: +977 1 436180
+977 1 428810
F: +977 1 436795
+977 1 416719
E: nepcraft@mos.com.np
W: www.astoria-hotel.com/nepalcrafts/index.htm
Contact Marie Jeanne Budé for information on hand papermaking workshops in Nepal.

THE NETHERLANDS

W Peter Gentenaar
Sir W. Churchillaan 1009
NL-2286 AD Rijswijk
T/F: +31 17 429 6961
E: gentor@hetnet.nl
Peter Gentenaar and Pat Torley-Gentenaar helped to organize the IAPMA Congress of 1994, with exhibitions of paper art in seven different locations in The Netherlands. Together, they help to organize and also publish the catalogue for the Holland Paper Biennal at the Museum Rijswijk.

H *De Middleste Molen*
(Arnold Zegers)
Kanaal-Zuid 499
NL-7371 GL Loenen
T: +31 55 505 2991

Mu *Museum Rijswijk*
Herenstraat 67
2282 BR Rijswijk
T: +31 70 390 3617
W: www.museumryswyk.nl
Following the success of the IAPMA Congress held in The Netherlands in 1994, the Museum Rijswijk has hosted the Holland Paper Biennal since it began in 1996 (*Tactile Paper*), followed by *Fire and Paper* in 1998 and *Paper and Water* in 2000. Work for the 2002 Biennal will be selected in October 2001. Submissions must be received no later than September 2001. Write for full details.

I *De Zaanische Molen*
Postbus 3
NL 1540 AA Koog aan de Zaan
West Zaan
T: +31 75 621 5148
F: +31 75 657 0308

H Mu *Papiermolen De Schoolmeester*
Guispad 3
1551 SX West Zaan
T: +31 75 621 4465
Original wind-powered papermill built in 1692, with a paper machine that dates from 1877. The only wind-driven papermill still in daily use.

NEW ZEALAND

H I *Kate Coolahan*
57 Sefton Street
Wadestown
Wellington
T/F: +64 (0) 4 473 5627
Trained on a Japanese cultural exchange in 1977 to make *washi* and conduct extensive research into native fibres. Paper plant museum and well-equipped studio (no courses).

H W *Mark Landers*
Lander Gallery
153 High Street
Oxford
North Canterbury
T: +64 (0) 3 312 4653
E: lander-gallery3@extra.co.nz

W *Marti Vreede*
Wanganui Polytechnic
Printworkshops
Wanganui
T: +64 (0) 6 345 0997
In charge of the most comprehensive (five-year) degree course in printmaking – with a papermaking module – in New Zealand.

NORWAY

A *PAN (Paper Art Norway)*
(Alison Leggat)
Manumit
Hik Avany 17
N-0287 Oslo 1
T/F: +47 22 43 83 39
E: alison@paperart.org
PAN is an organization that aims to promote contact between artists, craftspeople and others interested in handmade paper; increase knowledge of papermaking; and inspire co-operation between its members. One of its goals is to set up a workshop at least every second year. Asao Shimura (Philippines) has been invited to hold one on Japanese papermaking in 2002. This summer, in 2001, PAN will exhibit at the Kistefos Museum, which is housed in a wood-pulp mill dating from the nineteenth century.

THE PHILIPPINES

H I *Duntog Foundation Inc.*
(Michael Parsons, Director)
PO Box 254
Baguio City
T: +63 74 442 2881
F: +63 74 442 4291
Mill and study centre that focuses on indigenous fibres and traditional methods. Also workshops and artist residencies.

H I *Kami Philippines Inc, (KPI)*
(Asao Shimura)
Poking
Kapangan
2613 Benguet
T: +63 917 601 4241
Asao Shimura (Proprietor of Cannabis Press, Japan, since 1977), moved to the Philippines in 1989 and established Kami Philippines in 1993. It specializes in making *piña* paper and cloth (*shifu*) from the native pineapple, *ananas comosus Merr*. Asao still runs paper workshops and organizes tours in Japan (with flights and accommodation). Also publishes the *Piña* and *Shikat* newsletters.

POLAND

Mu *Museum Papiernictwa*
(Mrs Bozena Schweizer-Makowska, Director)
ul. Ktodza 42
57-340 Duszniki Zdrój
T: +48 (0)74 86 69 248
F: +48 (0)74 86 69 020
E: biuro@muzpap.pl
The Museum Papiernictwa was heavily damaged in the floods of July 1998, but reopened to the public in 1999. The papermill dates from 1605 and has been in operation for almost 400 years. Various activities to promote papermaking and related crafts include workshops for children, adults and artists. Once a month, the museum invites one artist to work at the museum for one week. Annual paper-art exhibition and occasional international workshops for artists. Host for the 14th IAPMA Congress in 2001 (2–8 August), and the 27th IPH Congress in 2004.

SOUTH AFRICA

W I *Technikon Natal*
(John Roome)
953 Durban 4000
T/F: +27 (0) 31 223 4405
University department with papermaking unit. Provides instruction as an optional part of the fine-art diploma and degree courses.

SPAIN

A *Assoc. Española de Papiroflexia*
Apartado de Correos 13156
28080 Madrid

H W Mu *Museu Moli Paperer de Capellades*
(Victoria Rabal Merola, Director)
pau Casals 10
08786 Capellades (Barcelona)
T/F: +34 93 801 28 50
E: museu@mmp-capellades.net
W: www.diba.es/museus/mmpc.htm
This entirely renovated eighteenth-century papermill was the largest and most upstream of the fourteen papermills in the town of Cappellades. Inaugurated in 1961, with the working mill preserved in the basement (using the original tools and machinery), the museum display includes the history of paper in Catalonia plus historical exhibitions demonstrating hand production in other

countries. It has continued to develop a full programme of paper activities, including workshops and seminars led by international papermakers and historians, and the upper storeys of the mill building are now fully restored. Candidate host for the 28th Congress of IPH in 2006.

SWEDEN

H W Mu *Grycksbo Pappersbruk*
Handpappersbruket
S-790 20 Grycksbo
T: +46 23 680 00

H W Mu *Handpappersbruket Lilla Götafors*
c/o Assarsson Lövgatan 6c
S-431 35 Ölndal
T: +46 31 27 1505
Located in the south of Sweden, this organization offers basic and advanced courses in papermaking to adults and children, as well as seminars, courses in bookbinding, workshops with paper artists and so on.

H *Sanny Holm*
Handpappersbruket
Frejgaten 36 4TR
S-113 26 Stockholm
T: +46 8 33 27 90
F: +46 8 31 20 96

W *MMartPaper*
(Margareta Mannervik)
Tångenvägen 4
S-430 91 Hönö
T/F: +46 31 96 70 00
E: s.mannervik@telia.com

H Mu *Tumba Bruk AB*
S-147 00 Tumba
Stockholm
T: +46 8 5786 95 00

W *Zen ArtPaper*
(Christina Bolling, Director)
St Jörgens väg 20D
S-422 49 Hisings Backs
Gothenburg
T: +46 31 55 68 55
F: +46 31 55 56 85
E: bolling@swipnet.se
zenart@algonet.se
Small papermill and workshops in papermaking.

SWITZERLAND

W *Atelierhaus*
(Therese Weber)
Fabrikmattenweg 1
CH-4144 Arlesheim
T/F: +41 61 701 91 07
E: therese_weber@mail.magnet.ch
Independent papermaking studio set up in 1988 by Therese Weber. Her interest is primarily in research, experimentation and the use of handmade paper as an art form. Artist collaborations and studio rental.

W *Atelier Viviane Fontaine*
CH-1654 Cerniat
T/F: +41 26 927 18 55
Workshops in papermaking, Japanese papermaking and sculptural techniques throughout the year.

Mu *Basler Papiermuhle*
St Alban-Tal 37
CH-4052 Basel
T: +41 272 9652
F: +41 272 0993
E: info@papiermuseum.ch
W: www.papiermuseum.com
Opened in 1980, the Basler Papiermuhle is a working museum with three focuses: paper, writing and printing.

Mu *Musée du Pays de Charmey*
(Patrick Rudaz, Curator)
Case Postale 5
CH-1637 Charmey
T: +41 26 927 24 47
F: +41 26 927 23 95
The Musée du Pays de Charmey hosts the International Triennale of Paper. The fourth exhibition will be held between 9 June – 8 September 2002. The theme is *Skin and Paper*. The exhibition is open to all artists who use paper other than as a support vehicle in creating their art. Write for details.

W *Papier Atelier*
(Suzanne Zehnder, Hubert Böckle)
Teufenerstrasse
CH-9000 St Gallen
T: +41 71 23 50 66
Workshop in a centre for adult education in arts and crafts: beginners and advanced papermaking courses, and theme-based workshops for artists who wish to broaden their papermaking skills. Papermaking space and equipment can also be hired to groups and schools. Papermaking supplies and equipment.

TAIWAN

Mu *Su Ho Memorial Paper Museum*
(Rita Chen, Director)
#68 Sec 2 Chang An E. Road
Taipei
Taiwan
T: +886 2 2507 5539
F: +886 2 2506 5195
E: paperfoundation@yahoo.com

UNITED KINGDOM

I *Apsley Paper Trail*
(Peter Ingram, Chief Executive)
The Cottage
Apsley Mill
London Road
Hemel Hempstead
Hertfordshire HP3 9RL
T: +44 (0)1442 263350
F: +44 (0)1442 232700

A chain of activities and exhibitions concentrated in the Frogmore Mill and Apsley Mill, focusing on handmade paper, machine-made paper (Fourdrinier), paper ecology, book binding and so on.

I *Art Bound*
Contemporary Book Works
(Sarah Bodman)
Centre for Fine Print Research
UWE, Faculty of Art, Media and Design
Clanage Road
Bristol
Avon BS3 2JT
T: +44 (0)117 344 4747
F: +44 (0)117 344 4824
E: Sarah.Bodman@uwe.ac.uk
W: colophon.com.Zybooks/sarah.html
A group of artists based in London and Bristol who specialize in handmade books, book objects and sculpture.

I *Book Works*
19 Holywell Row
London EC2A 4JB
T: +44 (0)20 7247 2536
F: +44 (0)20 7247 2540
E: mail@bookworks.org.uk
W: www.bookworks.org.uk
Since 1984 Book Works has aimed to question contexts for books in contemporary arts practice in a variety of ways: through exhibitions of artists' books, through commissioning installations and performances, through multi-location projects, and through its activities as a publisher, an informal resource and a production house.

A *British Association of Paper Historians (BAPH)*
Joan Marchant
47 Ellesmere Road
Chiswick
London W4 3EA
T: +44 (0)20 8995 8412
A national institution that aims to bring together individuals, companies and institutions with a common interest in paper and papermaking in all its forms and diversity. Publishes *The Quarterly*.

A *British Origami Society*
c/o Dave Brill
3 Worth Hall
Middlewood Lane
Poynton
Cheshire SK12 1TS
T: 01625 872509

I *Centre for Artist Books*
Visual Research Centre (DCA)
152 Nethergate
Dundee
Tayside
Scotland DD1 4DY
T: +44 (0)1382 348060
F: +44 (0)1382 348105
E: vrc@dundee.ac.uk

I W *Sophie Dawson*
19 The Priory
Middleton Street
Wymondham
Norfolk NR18 0AB
T: +44 (0)1953 605138
E: sophie.dawson@uea.ac.uk
Available for a range of workshops that aim to
further the craft across the broadest spectrum of
art and design and to encourage quality and
craftsmanship. Also papermaking supplies: pulp
and fibres can be beaten to specification in a
Hollander beater.

U *Duncan of Jordanstone College of Art and Design*
(Janet Shelley, Head of Department)
Constructed Textiles
Perth Road
Dundee
Tayside
Scotland DD1 4HT
T: +44 (0)1382 223261
Papermaking is offered to second-year students
within the textile course. A recently installed
Hollander beater is also available to printmaking
students in the Contemporary Arts Building.

I *Peter Ford (Director)*
Off-Centre Gallery
13 Cotswold Road
Bedminster
Bristol
Avon BS3 4NX
T/F: +44 (0)117 987 2647
E: offcentre@lineone.net
Organiser of *Made in Japan*, in collaboration with
the department of Eastern Art and Culture at Bristol
City Museum. *Made in Japan* is a touring exhibition
opening at Bristol City Museum from 8 September
to 4 November 2001, celebrating the varied uses of
paper in contemporary Japanese art. Artists taking
part include Kyoko Ibe, Shoichi Ida, Makiko
Azakami, Tomie Kondon and Kunito. The exhibition
is part of the *Japan 2001* festival.

U *Glasgow School of Art*
(Jacki Parry, Head of Department)
Printmaking
167 Renfraw Street
Glasgow
Strathclyde
Scotland G3 6RQ
T: +44 (0)141 353 4500

I *Philip Gumuchdjian*
Gumuchdjian Associates
67 Shelton Street
London WC2H 9HE
T: +44 (0)20 7379 7010
F: +44 (0)20 7379 7011
The Paper Forest Pavilion is the first permanent
paper building in Britain. In May 2000 the Royal
Botanical Gardens commissioned Shigeru Ban in
collaboration with Gumuchdjian Associates and
Buro Happold engineers to design a new

Conservation Activity Centre at the heart of the
gardens' conservation area. In its first year of use
the building is intended to act as flagship for the
Japan 2001 festival, bringing a strong environmental
focus to this major cultural exchange. The
building's structure is made of recycled cardboard
paper tubes (comprising thirty-two layers of
bonded paper), and will provide a focus for and
interpretation of sustainability projects worldwide.

I *The Hardware Gallery*
162 Archway Road
London N6 5BB
T: +44 (0)20 8341 6415
F: +44 (0)20 8348 0651
The leading stockist of artists' books in the UK.

W *Chrissie Heughan*
3 Oxford Street
Edinburgh
Lothian
Scotland EH8 9PH
T: +44 (0)131 667 8728
Individual tuition offered by Chrissie Heughan in
her papermaking studio. Available for lectures.
Range of papermaking supplies. Also runs short
summer courses at Edinburgh College of Art.

I *Institute of Paper Conservation*
Leigh Lodge
Leigh
Worcestershire WR6 5LB
T: +44 (0)1886 833688
E: information@ipc.org.uk
Leading organization devoted solely to the
conservation of paper and related materials.

U *London College of Printing*
School of Printing and Publishing
Elephant and Castle
London SE1 6SB
T: +44 (0)20 7735 8484
Three-year BA (Hons.) book arts and crafts: a
project-based course designed to create
opportunities to explore the art and craft of the
book in all its aspects. Higher National Diploma in
design bookbinding: a practice-based programme
in the creative craft of bookbinding. Also part-time
courses in craft bookbinding, creative bookbinding,
intermediate and advanced craft bookbinding. The
publication *Floodlight* provides a comprehensive
list of full-time and part-time courses in the Greater
London area.

U *Loughborough University School of Art and
Design*
(Karen Legg)
Fine Art Printmaking Department
Epinal Way
Loughborough
Leicestershire LE11 3TU
T: +44 (0)1509 228951
E: K.Legg@lboro.ac.uk
Thirty years of research and practice, inaugurated
by Dave Gibbs in 1970, and now established as

one of the leading papermaking and book arts
programmes in the UK.

I *Marcus Campbell Art Books*
43 Holland Street
London SE1 9JR
T: +44 (0)20 7261 0111
F: +44 (0)20 7261 0129
E: campbell@marcuscampbell.demon.co.uk
For information on The London Artists' Book Fair,
the largest platform for makers, artists and
collectors of artists' books in the UK to date,
reflecting the current growth of interest in this
immensely diverse genre. The fair, which lasts for
three days, is usually held at the beginning of
November at the Barbican Centre in London.

Mu *Museum of Science and Industry*
Liverpool Road
Manchester M3 4FP
T: +44 (0)161 832 2244
F: +44 (0)161 833 2184
W: www.msim.org.uk
Holds on loan the collections of the National Paper
Museum Trust. The museum's archive contains a
collection of paper and watermark samples and a
collection of published sources on the international
history of papermaking. These can be viewed by
appointment. The museum's Education Service can
run activity sessions about papermaking on request.
Education Service
T: +44 (0)161 833 0027
F: +44 (0)161 832 1511
E: all@mussci.u-net.com
W: www.edes.co.uk/mussci

W *Nautilus Press and Papermill*
(Jane Reese)
107 Southern Row
London W10 5AL
T: +44 (0)20 8968 7302
F: +44 (0)20 8968 6309
Papermaking studio (part of a complex of
printmaking, binding and papermaking
opportunities) in London.

U *Oxford Brookes University*
School of Art, Publishing and Music
The Richard Hamilton Building
Headington Hill Campus
Oxford OX3 0BP
T: +44 (0)1865 484951
F: +44 (0)1865 484952
E: apm@brookes.ac.uk
Oxford Polytechnic (now Oxford Brookes
University) established a Paperworks Studio in
1986, and a Fellowship was initially funded for one
year. Originally part of the Book Works department
led by Ivor Robinson, the hand-papermaking
module is no longer a part of the curriculum.
However, most of the papermaking equipment
(Reiner beater, a range of quality moulds, large
wooden screw press and other pieces) is still
available to undergraduate students on the
contemporary fine art and foundation courses.

A *Paperweight*
(Rachel Woodhouse, Membership Secretary)
19 Station Road
Harpendon
Hertfordshire AL5 4XD
T: +44 (0)1582 712138
E: r.woodhouse@ukgateway.net
A nationwide group for papermakers and artists across the UK, which aims to bring people together with an interest in paper – from the artistic, sheet-forming, conservation and sustainable-resource points of view.

I *The Paper Shed*
(Kath Russon)
March House
Tollerton
North Yorkshire YO6 2EP
T: +44 (0)1347 838253
F: +44 (0)1347 838096
W: www.papershed.com

W *The Paper Workshop*
(Jacki Parry)
Gallowgate Studios
15 East Campbell Street
Glasgow
Strathclyde
Scotland G1 5DT
T: +44 (0)141 552 4353

H *Plant Papers Mill*
(Maureen Richardson)
Romilly
Brilley
Herefordshire HR3 6HE
T: +44 (0)1497 831546
F: +44 (0)1497 831327
Maureen Richardson is an experienced hand papermaker, well known for her wide range of plant-fibre papers. She is currently Chairman of Paperweight (see above).

H W *Two Rivers Paper Company*
(Jim Patterson)
Pitt Mill
Roadwater
Watchet
Somerset TA23 0QS
T: +44 (0)1944 641028
F: +44 (0)1984 640282
Core business of rag watercolour-paper production but in addition some papermaking workshops and courses. Studio and workshop facilities for experienced papermakers to work more independently are also available. The mill is open to visitors during working hours.

H Mu *Wookey Hole Caves & Mill Ltd*
Wookey Hole
Wells
Somerset BA5 1BB
T: +44 (0)1749 672243
F: +44 (0)1749 677749
E: witch@wookeyhole.demon.co.uk

Probably the only remaining papermill producing handmade paper in the country; also a locally owned tourist attraction.

UNITED STATES

W *Arizona State University*
(Professor John Risseeuw)
School of Art
Tempe
AZ 85287-1505
T: +1 (480) 965 3713
F: +1 (480) 965 8338
E: john.risseeuw@asu.edu
Fine printing (letterpress) and bookmaking, papermaking, photographic processes for printmaking, artists' books. MFA programme.

W *Arrowmont School of Arts and Crafts*
PO Box 567
Gatlinburg
TN 37738-0567
T: +1 (413) 436 5860
E: arrowmnt@aol.com
W: www.arrowmont.org
Programme of workshops in book arts, printmaking and paper arts with nationally and internationally renowned artists.

W I *The Bookbinders of California*
PO Box 193216
San Francisco
CA 94119
T: +1 (415) 565 0545
E: info@sfcb.org
The San Francisco Center for the Book is an educational centre for anyone interested in the arts of the book.

H W *Carriage House Paper*
(Donna Koretsky, Shannon Brock, Dean Ebben)
79 Guernsey Street
Brooklyn
NY 11222
T/F: +1 (718) 599 7857
E: chpaper@aol.com
A major teaching and papermaking facility. Studio services include short, specialized and intensive workshops throughout the year, as well as rental of papermaking facilities. Also a showroom for handmade paper, papermaking equipment and supplies.

Carriage House Studio
8 Evans Road
Brookline
MA 02146
T: +1 (617) 232 1636
F: +1 (617) 277 7719
E: paperraod@aol.com
(see The Research Institute of Paper History and Technology below)

H W *Cave Paper*
(Amanda Degener, Bridget O'Malley)
1334 6th Street NE
Minneapolis
MN 55413
T/F: +1 (413) 359 0645
E: Amanda_Degener@mcad.edu
W: www.Cavepaper.com
A production studio making high-quality paper in Minneapolis. Internships. Amanda Degener is a paper artist and sculptor who works with graduate students and also teaches courses on book arts, papermaking and sculpture.

W I *Center for Book Arts*
626 Broadway
New York
NY 10012
T: +1 (212) 460 9768
Dedicated to preserving the traditional crafts of bookmaking as well as exploring and encouraging contemporary interpretations of the book as an art object. Workshops in papermaking, printing and book arts.

W *Columbia College Chicago Center for Book and Paper Arts*
(William Drendel, Director)
1104 South Wabash Avenue
2nd Floor
Chicago
IL 60605
T: +1 (312) 344 6630
F: +1 (312) 344 8082
E: book&paper@popmail.colum.edu
W: www.column.edu/centers/bpa
MFA programme in interdisciplinary book and paper arts; letterpress printing and photography; community classes and workshops; graduate and undergraduate classes; workshops, studio rental. Lectures, exhibitions and events. Host for the 15th IAPMA Congress in 2002.

I *Crossing Over Consortium, Inc.*
(Jane Farmer)
3724 McKinley Street NW
Washington, DC 20015-2510
T: +1 (202) 966 4828
F: +1 (202) 244 5952
E: consort@erols.com
For international exchange: paper, prints and book arts. See also <info@paperroadtibet.org>.

H W *Dieu Donné Papermill, Inc*
(Mina Takahashi, Paul Wong)
433 Broome Street
New York
NY 10013-2622.
T: +1 (212) 226 0573
F: +1 (212) 226 6088
E: ddpaper@cybernex.net
W: www.colophon.com/dieudonne
Dieu Donné is a non-profit-making organization founded in 1976, dedicated to advancing the art of hand papermaking by collaborating with artists,

creating custom-designed papers, presenting exhibitions and conducting educational programmes for adults and children. It offers a studio rental programme as well as an internship programme and work-exchange programme. It also houses a library, slide registry, and archive of handmade paper and paper art, and sponsors lectures on topics related to hand papermaking.

H W *Dobbin Mill*
(Robbin Ami Silverberg, Director)
50–52 Dobbin Street
Brooklyn
NY 11222
T: +1 (718) 388 9631
F: +1 (718) 388 9612
E: DobbinMill@aol.com
An artists'-book studio and papermill that comprises a large papermaking studio, an artists'-book studio, a darkroom and a private courtyard for working outdoors. The mill makes standard and custom handmade papers. Workshops offered, mainly via the Center for Book Arts in New York. Internship programme and collaboration opportunities.

W *Fabrile Studio*
PO Box 1551
Taos
NM 87048
T: +1 (505) 751 0306
Workshops in papermaking.

A *Friends of Dard Hunter (FDH), Inc.*
PO Box 773
Lake Oswego
OR 97034
T/F: +1 (503) 699 8653
E: instar@teleport.com
W: www.slis.ua.edu/book.html
An international, non-profit-making organization, founded in 1981, the original goal and purpose of which was the celebration of what has become the Dard Hunter Collection of the American Paper Museum, now administered by the Institute of Paper Science and Technology in Atlanta, Georgia. FDH publishes a newsletter and annual membership directory, and holds an annual meeting for members to exchange information. The seventeenth annual meeting will be held in Dalton, Massachussetts, October 24–28, 2001.

I *Hand Papermaking Inc.*
PO Box 77027
Washington, DC 20012-7027
T: +1 (301) 220 2393
Toll-free 0800 821 6604
E: handpapermaking@bookarts.com
W: www.handpapermaking.org
A non-profit-making organization dedicated to advancing traditional and contemporary ideas in the art of hand papermaking through publications and other educational formats. Publishes Hand Papermaking magazine (bi-annual) and a newsletter. Reviews of current exhibitions, books and other materials or events of interest to its readers; series of occasional articles that look at papermaking in various geographical locations. In 1988 established a slide registry from which two juried slide kits and a video have been produced. In 1994 Hand Papermaking presented the first in a bi-annual series of limited-edition portfolios of handmade papers.

W *Haystack Mountain School of Crafts*
PO Box 518HP
Deer Isle
ME 04627
T: +1 (207) 348 2306
Hand papermaking, book arts, printmaking and graphics.

W Mu *Historic RittenhouseTown*
206 Lincoln Drive
Philadelphia
PA 19144
T: +1 (215) 843 2228
F: +1 (215) 849 6447
E: HistRitTwn@aol.com
RittenhouseTown is the site of the first paper mill in British North America, founded in 1690 by William Rittenhouse, now conserved as a museum and research centre. Papermaking workshops, tour of site and demonstrations.

W *Icosa Studio and Mill*
(Margaret Ahrens Sahlstrand)
12060 Highway 10
Ellensburg
WA 98926
T/F: +1 (509) 964 2341
E: sahlstrand@elltel.net
Hand papermill with educational programmes on Korean and Japanese papermaking and Japanese paper clothing (*shifu* and *kamiko*).

W *LaPlantz Studios*
(Shereen LaPlantz)
PO Box 160
Bayside
CA 95544
T/F: +1 (707) 839 9554
Artist's books and workshops, including a three-year programme.

H *MacGregor and Vinzani Hand Papermakers*
PO Box 70
Old Cutler Road
Whiting
ME 04691
T: +1 (207) 733.2472
Special makes for letterpress printers, bookbinders, conservators, calligraphers, printmakers and other artists.

H W *Magnolia Editions*
(David Kimball)
2527 Magnolia Street
Oakland
CA 94607
T: +1 (510) 839 5268
F: +1 (510) 893 8334
E: dkimball@rocketmail.com
Magnolia Editions comprises a paper workshop and fine-art print studio. It makes custom papers and offers collaborative facilities to artists. It is also open to the public and organizes tours and classes for institutions, schools and so on.

W *Minnesota Center for Book Arts*
24 North 3rd Street
Minneapolis
NM 55401
T: +1 (612) 338 3634
Aims to advance the book as a vital contemporary art form, as well as to preserve the traditional craft of bookmaking, through exhibitions, education and book production. Workshops in papermaking and book arts.

W *Catherine Nash*
1102 West Huron Street
Tucson
AZ 85745
T: +1 (520) 740 1673
F: +1 (520) 620 6613
E: rfrow@azstarnet.com
Catherine Nash has studied the techniques of Japanese woodcut and papermaking during two visits to Japan. An artist-in-residence for the Arizona Commission on the Arts, she teaches papermaking and artist books in Arizona schools and has taught advanced workshops in paper art and sheet forming across the USA and Western Europe.

A *Origami USA*
15 West 77th Street
New York
NY 10024-5192
T: +1 (212) 769 5635
F: +1 (212) 769 5668
A non-profit-making, educational and cultural arts organization dedicated to the sharing of paper folding in America and around the world.

W *Oxbow Summer School of Art*
Saugatuck MI
c/o Office of Summer Programs
The School of the Art Institute of Chicago
37 South Wabash Avenue
Chicago
IL 60603
T: +1 (312) 899 5130
+1 (312) 443 3777

I *Paper and Book Intensive*
(Steve Miller, PBI Co-director)
The University of Alabama/School of Library and Information Studies
Box 870252
Tuscaloosa
AL 35487-0252
T: +1 (205) 348 1525
E: smiller@slis.ua.edu
W: www.slis.ua.edu/ba/pbi/html

Write for information, or to apply for this year's Paper and Book Intensive (PBI), an annual meeting of book-art professionals, held in different geographical regions of the country each year. Now in its eighteenth year, PBI offers a concentrated working session for enthusiasts and practitioners in the book arts, papermaking and conservation.

I *Paper Jargon*
PO Box 10070
Glendale
AZ 85318
W: www.paperjargon.com

W *Paper Press*
1017 West Jackson
Chicago
IL 60607
T: +1 (312) 226 6300
Workshops in papermaking and related arts.

W *Penland School of Crafts*
PO Box 37
Penland
NC 28765
T: +1 (828) 765 2359
F: +1 (828) 765.7389
E: office@penland.org
W: www.penland.org
A non-profit-making organization and national centre for craft education located in the Blue Ridge Mountains of Western North Carolina. Penland offers a variety of workshops in book and paper, clay, drawing, glass, iron, metals, photography, printmaking, textiles, and wood. The school also sponsors residencies and educational outreach programmes.

H W *Pyramid Atlantic*
(Helen Frederick, Director)
6001 66th Avenue
Suite 103
Riverdale
MD 20737
T: +1 (301) 459 7154
+1 (301) 577 3424
F: +1 (301) 577 8779
E: pyratl@earthlink.net
W: www.pyramidatlantic.org
A non-profit-making organization founded in 1981 to foster collaborative exchange between artists, experimentation and innovation in the field of prints, paper and the art of the book, and international cultural exchange programmes. The centre provides access to equipment and technical expertise through rental of its papermill and printshop; workshops, master classes, exhibitions, lectures, demonstrations, and a resource library and gallery. Pyramid Atlantic is forming a partnership with a new media group, and developing a new programme called Site for Electronic Media, Art and Technology (SEMAT) to expand and enhance its educational and international art exchange programmes. It will locate to a new site in Maryland, scheduled to open in winter 2002. Artist residency and internship programme.

H W Mu *The Research Institute of Paper History and Technology*
(Elaine Koretsky)
Carriage House
8 Evans Road
Brookline
MA 02146
T: +1 (617) 232 1636
F: +1 (617) 277 7719
E: paperroad@aol.com
The first hand-papermaking studio in Massachusetts, established in 1975 by Elaine Koretsky and Donna Koretsky. Now re-organized as a non-profit-making research institute, still with an active papermaking studio and complete facilities. The library and museum features a collection of old, rare and modern books concerning paper history, the technology of papermaking and manuscripts illustrating book forms in many ancient cultures; handmade papers; and tools, equipment and artefacts relating to historical papermaking that have been gathered from all over the world. Elaine and Donna Koretsky/Carriage House Paper lead regular papermaking tours, most recently to Burma and Thailand in November 2000.

I Mu *Robert C. Williams American Museum of Papermaking*
500 10th Street NW
Atlanta
GA 30318
T: +1 (404) 894 6663
F: +1 (404) 894 4778
W: www.ipst.edu/amp.html
An internationally renowned resource on the history of papermaking and paper technology, and the premier collection of paper and paper-related artefacts in the world. National touring exhibition programme, seminars and workshops. Host site for the Annual Meeting of the Friends of Dard Hunter in October 2000.

W *Rugg Road Papers and Prints*
(Bernie Toale, Joe Zina)
1 Fitchburg Street, Suite B154
Somerville
MA 02143
T: +1 (617) 666 0007

W *San Francisco Center for the Book*
300 Deharo Street
San Francisco
CA 94103
T: +1 (415) 565 0545
F: +1 (415) 565 0556
E: info@sfsb.org
Offers classes, workshops, exhibitions on book arts.

H W *Sea Pen Press and Papermill*
(Neal Bonham, Suzanne Ferris)
2228 NE Street
Seattle
WA 98105
T: +1 (206) 522 3879
Custom pulp and paper.

W *Seastone Papers*
(Sandy Bernat)
Box 351
West Tisbury
Martha's Vineyard
MA 12575
T: +1 (508) 693 5786
E: sbernat@tiac.net
W: www.tiac.net/users/sbernat
Seastone Papers is a teaching studio with workshops at present in the spring and summer months. Visiting artists/instructors. Annual workshop with intensive focus and/or theme, 2001's being 'A Journey into Nature', with the emphasis on exploring the natural beauty of Martha's Vineyard.

I *Keith Smith Books*
(Keith A. Smith)
22 Cayuga Street
Rochester
NY 14620-2153
T: +1 (716) 474 6776
E: ksbooks@netacc.net/Books on books
W: net2.netacc.net/~ksbooks

W *Bonnie Stahlecker*
6819 Sunrise Drive
Plainfield
IN 46168
T: +1 (317) 839 4397
Limited edition books, available for workshops in dimensional books.

W *Southwest Craft Center*
300 Augusta
San Antonio
TX 78205
T: +1 (512) 224 1848
Organized to promote local education in the arts; ongoing classes and workshops in papermaking and related arts; exhibitions and studio opportunities for both local and nationally known artists.

W *Submarine Paperworks*
(Joan Rhine and Jim Meilander)
PO Box 885082
San Francisco
CA 94188
T: +1 (415) 822 7647
Papermaking workshops, studio rental, editioning services, supplies.

Marilyn Sward
1218 Asbury
Evanston
IL 60202
T: +1 (847) 492 9647
F: +1 (312) 986 8237
E: msward@popmail.colum.edu

W Taos Paperworks
PO Box 3162
Taos
NM 87571
T: +1 (505) 758 8589
Weekend workshops throughout spring and summer.

H Twinrocker Handmade Paper
(Kathryn and Howard Clark)
PO Box 413
100 East Third Street
Brookston
IN 47923
T: +1 (765) 563 3119
F: +1 (765) 563 8944
E: twinrock@twinrocker.com
W: www.twinrocker.com
Kathyrn and Howard Clark founded Twinrocker in 1971, the first hand papermill in America to go on-line. Extensive collaboration with artists; qualified apprentices accepted for study. Custom and stocked handmade papers. Book arts and papermaking supplies. The mill is committed to education concerning the history and process of papermaking and welcomes invitations to lecture and run workshops. Private workshops for groups or individuals in papermaking, letterpress printing or book arts can be arranged by appointment.

W University of Alabama/SLIS
(Professor Steve Miller)
Letterpress printing and hand papermaking
Box 870252
Tuscaloosa
AL 35487-0252
T: +1 (205) 348 1525
W: www.slis.ua.edu/ba/books.html
The MFA in the Book Arts Programme is now in its thirteenth year and emphasizes the craft and art of making books by hand.

W University of the Arts
(Mary Phelan, Book Arts, Printmaking)
320 South Broad Street
Philadelphia
PA 19102
T: +1 (215) 875 1119
T: +1 (215) 875 2238
E: maryphelan@aol.com

W University of Iowa Center for the Book
(Timothy Barrett, Director of Paper Facilities)
152 English-Philosophy Building
University of Iowa
Iowa City
IA 52242
T: +1 (319) 335 4410
E: center-for-the-book@iowa.edu
W: www.uiowa.edu/~ctrbook/
Academic programme, publications, credit and non-credit bookmaking classes. Five videotapes, written by Timothy Barrett, that cover Japanese style and Western papermaking techniques and equipment. Write for details.

W University of Maine Machias
(Bernie Vinzani, Associate Professor of Art)
University of Maine at Machias
9 O'Brien Avenue
Machias
ME 04654-1397
T: +1 (207) 255 1200
E: admissions@acad.umm.maine.edu
W: www.umm.maine.edu/faculty/bvinzani
Teaching specialities: design, drawing, printmaking, book arts, papermaking.

W Visual Studies Workshop
31 Prince Street
Rochester
NY 14607
T: +1 (716) 442 8676
Workshops in book arts.

H W Waterleaf Mill and Bindery and Pequeno Press
(Pat Baldwin, Director)
PO Box 1711
Bisbee
AZ 85603
T: +1 (520) 432 5924
F: +1 (520) 432 3065
E: patbooks@primenet.com
W: www.primenet.com/~patbooks/
Papermaking instruction and mill rental. Also offers traditional apprenticeships to those interested in the techniques of papermaking, marbling and bookbinding; also the process of limited-edition book production and the ins and outs of running a small business.

W Water Mark Mill and Press
(Coco Gordon)
138 Duane Street
New York
NY 10013
T: +1 (212) 285 1609
Artist's books, paper consultation, permaculture and art projects.

W Widgeon Cove Studios
(c/o Georgeann Kuhl)
RR1, Box 62
Harpswell
ME 04079
T: +1 (207) 833 6081
Range of workshops in papermaking.

W Wild Fibres
Mailyn Wold
PO Box 4202
Aloha
OR 97006
T: +1 (503) 641 2294
F: +1 (503) 641 7964
Yearly workshops and retreats.

Women's Studio Workshop
PO Box 489
Rosedale
NY 12472-9031
T: +1 (914) 658 9133
F: +1 (914) 658 9031
E: wsw@ulster.net
W: www.wsworkshop.org
Intensive workshops on printmaking, papermaking, book arts, photography and other traditional media. Classes run summer to autumn. Residencies, grants and fellowships: designed to provide concentrated worktime for artists to explore new ideas in a dynamic and supportive community of women artists. Facilities include intaglio, silkscreen, hand papermaking, photography and letterpress. Two- to six-week sessions are available each year from September to June. The cost to recipients is $200 per week plus materials. The award includes on-site accommodation and unlimited access to the studios.

ZIMBABWE
H W Walter Ruprecht
Cartolina Handmade Papers
PO Box ST 659
Southerton
Harare
E: cartlina@mweb.co.zw
Cartolina has grown to become Handmade Paper of Africa, which now embraces sixteen other community-owned projects in rural Zimbabwe, making a series of African papers using agricultural waste from food crops and sisals. Cartolina caters mainly for papers made from cotton rag, which it collects from the garment industries.

PICTURE CREDITS

Illus. pp. 50–51 © Peter Abrahams

Illus. p. 78 © Jess Ahmon

Fig. 12 courtesy of Anderson O'Day Graphics

Illus. p. 66 (left) © Carol Andrews

Illus. p. 45 (bottom) courtesy of the artists

Illus. pp. 100, 101 courtesy of the artist

Illus. pp. 106, 107 courtesy of the artist

Illus. p. 65 © P. Ashworth

Figs. 8–10, 18 © Ed Barber

Illus. p. 57 courtesy of Jonathan Baxter

Illus. pp. 48, 49 © Les Bicknell

Illus. p. 87 © Michael Black

Fig. 21 © Adrian Burrows, courtesy of Ikon Gallery, Birmingham

Fig. 6 © David Cripps

Illus. p. 66 (right) © Damian Cruikshank

Illus. p. 104 © Geraint Cunnick

Illus. pp. 6, 92 © Susan Cutts

Fig. 17 courtesy of English National Ballet

Illus p. 39 (bottom) © Jennie Farmer

Fig. 3, illus. p. 59 © Vincent Floderer

Illus. p. 36 © Victor France

Illus. p. 64 © Tomoko Fuse

Fig. 1 courtesy of Gavin Brown's enterprise, New York

Frontispiece, illus. pp. 1, 14, 26, 37 (left), 38, 39 (top), 40 (bottom), 41, 42, 43, 44, 45 (top), 46, 47, 58, 67, 75, 76 (left), 77, 79 (left), 82, 83, 84 (bottom), 85, 94, 95, 103, 128 © Peter Greenhalf

Illus. p. 89 © Paul Highnam

Fig. 19 © Cas Holmes

Illus. p. 40 (top) © Carl Jaycock

Illus. p. 86 © Paul Johnson

Illus. p. 105 (bottom) © Sarah Jones

Fig. 16, illus. p. 105 (top) © George Ktistakis

Illus. p. 102 © Sue Lane

Fig. 11 © Marcia Lochhead

Illus. p. 84 (top) © Martin Marenčin

Illus. pp. 80–81 © Katsutoshi Motomatsu

Fig. 13, illus. pp. 34–35 © Marilyn Muirhead

Fig. 7 © The Museum of Modern Art, New York

Illus. p. 76 (right) © Peter Niczewski

Illus. pp. 108, 109 © Ei Oiwa

Illus. p. 99 © Angela O'Kelly

Illus. p. 93 © Joseph Painter

Illus. pp. 60, 61 © Michel Planchenault

Fig. 15, illus. pp. 55, 56 courtesy of Asahi Shinbunsha

Illus. p. 37 (right) © Andrea Stanley

Illus. pp. 70, 71, 72, 73 © Charlie Thomas

Illus. pp. 96, 97 © Malcolm J. Thomson

Fig. 20 © Shannon Tofts, courtesy of The Gallery, Ruthin Craft Centre

Illus. p. 98 © Nick Turner

Illus. p. 10, figs. 4–5 courtesy of the Victoria and Albert Museum, London

Illus. p. 88 © Lois Walpole

Illus. p. 74 © Alison Wilson-Hart

Fig. 2, illus. pp. 62, 63 © Derek E. Witty

Fig. 14, illus. p. 54 courtesy of Akira Yoshizawa

SELECTED BIBLIOGRAPHY

All Japan Handmade Washi Association, *A Handbook on the Art of Washi*, London 1991

Barrett, Timothy, *Japanese Papermaking: Traditions, Tools and Techniques*, New York and Tokyo 1983

Bawden, Juliet, *The Art and Craft of Papier Mâché*, London 1990

Bell, Lillian, *Papyrus, Tapa, Amate and Rice Paper*, McMinnville OR 1981; revised edn 1988

Bell, Lillian, *Plant Fibres for Papermaking*, McMinnville OR 1981; revised edn 1988

Biddle, Steve, and Megumi Biddle, *The New Origami*, New York 1993

Bolton, Claire, *AwaGami: Japanese Handmade Papers from the Fuji Mills*, Tokushima and Abingdon 1992

Bury, Stephen, *Artists' Books: The Book as a Work of Art 1963–1995*, Aldershot 1998

Cunning, Sheril, *Handmade Paper: A Practical Guide to Oriental and Western Techniques*, Escondido CA 1982

Dawson, Sophie, *The Art and Craft of Papermaking*, London 1992; New York 1992; East Roseville NSW, Australia, 1992; Freiburg im Breisgau, Germany, 1994; Paris 1994; Asheville NC 1997

Dawson, Sophie, and Silvie Turner, *A Hand Papermaker's Sourcebook*, London 1995; New York 1995

Diringer, David, *The Book before Printing*, New York 1982

Doggett, Sue, *Bookworks*, London 1998

Eimert, Dorothea, *Paper Art: History of Paper Art*, Düren 1994; published on the occasion of PaperArt 5

Engel, Peter, *Origami from Angelfish to Zen*, New York 1994

Farnsworth, Don, *A Guide to Japanese Papermaking*, Oakland CA 1989

Field, Dorothy, *Handmade Paper in Nepal: Tradition and Change*, 3rd Portfolio of Hand Papermaking, Washington, DC, 1998

Fischel, Cathy, *Paper Graphics: The Power of Paper in Graphic Design*, Gloucester MA 1999

Fox, Gabrielle, *The Essential Guide to Making Handmade Books*, Cincinnati OH 2000

Fuse, Tomoko, *Joyful Origami Boxes*, Tokyo 1996

Gault, Rosette, *Ceramics Handbook: Paper Clay*, London 1997

Gentenaar, Pat, and Peter Gentenaar, *Paper and Water*, Rijswijk 2000

Goldman, Saundra, *Explorations in Handmade Paper: A Selection of Work from Rugg Road*, exhib. cat., Lincoln MA, DeCordova Museum and Sculpture Park, 1989

Harbin, *Origami: Teach Yourself*, London 1992

Heller, Jules, *Papermaking*, New York 1978

Hiebert, Helen, *Papermaking with Plants*, Downall VT 1998

Hills, Richard, *Papermaking in Britain 1488–1988: A Short History*, London 1988

Hughes, Suki, *Washi: The World of Japanese Paper*, Tokyo, New York and San Francisco 1978

Hunter, Dard, *Papermaking: The History and Technique of an Ancient Craft*, New York 1978

Ikegami, Kojiro, *Japanese Bookbinding: Instructions from a Master Craftsman*, Tokyo 1979

International Biennale of Paper Art, *PaperArt*, exhib. cat., Düren, Leopold-Hoesch-Museum, 1996

Jackson, Paul, *The Encyclopedia of Origami and Papercraft Techniques*, London 1991

James, Angela, *The Handmade Book*, London 2000

Johnson, Arthur, *The Practical Guide to Craft Bookbinding*, London 1985

Johnson, Paul, *Pop-up Paper Engineering: Cross Curricular Activities in Design Engineering Technology, English and Art*, London 1992

Johnson, Pauline, *Creative Bookbinding*, New York 1990

Kasahara, Kunihiko, and Toshie Takahama, *Origami for the Connoisseur*, Tokyo, New York and San Francisco 1998

Koretsky, Elaine, *Colour for the Hand Papermaker*, Brookline MA 1983

Koretsky, Elaine, *A Gathering of Papermakers*, Brookline MA 1988

Koretsky, Elaine, and Donna Koretsky, *The Goldbeaters of Mandalay*, Brookline MA 1991

Krill, John, *English Artists Paper, Renaissance to Regency*, London 1987

LaFosse, Michael, *Paperart: The Art of Sculpting with Paper*, Gloucester MA 1998

LaFosse, Michael, *Origamido: The Art of Folded Paper*, Gloucester MA 2000

Lang, Robert J., *The Complete Book of Origami*, New York 1990

LaPlanz, Linda, *Cover to Cover: Creative Techniques for Making Beautiful Books, Journals and Albums*, New York 1998

Long, Paulette (ed.), *Paper: Art and Technology*, San Francisco 1979

Macfarlane, Nigel, *A Paper Journey, Travels among the Village Papermakers of India and Nepal*, Newcastle DE 1993

McDonald, Lee (ed.), *Beater Builders of North America 1946–89*, Buffalo NY 1990

Montroll, John, *Origami Sculpture*, New York 1991

New Paper Crafts, London 1998

Niles, Bo, *Paperie: The Art of Writing and Wrapping with Paper*, East Roseville NSW, Australia, 1999

Plowman, John, *The Craft of Handmade Paper: A Practical Guide to Papermaking Techniques*, London 1997

Premchand, Neeta, *Off the Deckle Edge*, Bombay 1995

Ramshaw, Wendy, and David Watkins, *The Paper Jewelry Collection*, London 2000

Richards, Constance E., *Making Books and Journals*, New York 2000

Richardson, Maureen, *An Alternative to the Beater*, Hereford 1990

Richardson, Maureen, *Handmade Paper*, London 1999

Rodin, Bo, *Making Paper: A Look into the History of an Ancient Craft*, Vällingby, Sweden, 1990; New York 1990

Rolo, Jan, and Ian Hunt (eds.), *Bookworks: A Partial History and Sourcebook*, London 1988

Roukes, Nicholas, *Sculpture in Paper*, Worcester MA 1993

Shannon, Faith, *The Art and Craft of Paper*, London 1994; previously published as *Paper Pleasures: From Basic Skills to Creative Ideas*, London 1987

Simon, Lewis, *Modular Origami Polyhedra*, New York 1999

Smith, Gloria Zmolek, T*eaching Hand Papermaking: A Classroom Guide*, Iowa City IA 1995

Smith, Keir, *Non-Adhesive Binding: Books without Paste or Glue*, Rochester NY 1990

Stearns, Lynn, *Papermaking for Basketry*, Asheville NC 1992

Stevens, Clive, *Papercraft School*, Surry Hills NSW, Australia 1996

Studley, Vance, *The Art and Craft of Handmade Paper*, New York 1997

Thompson, Claudia G., *Recycled Papers: The Essential Guide*, Cambridge MA 1992

Toale, Bernard, *The Art of Papermaking*, Worcester MA 1983

Turner, Silvie, *Which Paper? A Guide to Fine Papers for Artists, Craftspeople and Designers*, London and New York 1990

Turner, Silvie, *The Book of Fine Paper*, London 1998

Turner, Silvie, and Birgit Skjold, *Handmade Paper Today*, London 1983

Turner, Silvie, and Ian Tyson, *British Artists' Books: A Survey 1983–1993*, London 1993

Vilsbøll, Anne, *Paper Road: Communication Today*, Copenhagen 1996

Wilcox, Annie Tremmel, *A Degree of Mastery*, London 2000

Williams, Nancy, *Paperwork: The Potential of Paper in Graphic Design*, London 1993

Zeigler, Kathleen, *Paper Sculpture: A Step by Step Guide*, Gloucester MA 1996

Zeir, Franz, *Books, Boxes and Portfolios: Binding, Construction and Design*, New York 1990

INDEX

Page numbers in *italics* refer to illustrations

Ahmon, Jess 69; *78*
Andrews, Carol 22; *66*
Atkinson, Jon 24; *94–95*
Ayers, Linda 24
Azakami, Makiko 121
Azumi, Tomoko *12*

Bajus, Jozef 69; *84–85*
Ban, Shingeru 21, 121
Barker, Laurence 17
Baxter, Penny *44–45*
Becker, Helmut 115
Bicknell, Les 25, 33; *48–49*
Burnfield, Penny 69; *82–83*

Chatani, Masahiro 20
Clifford, Grace *65*
Corr, Mhairi 24; *24*
Correia, Jean-Claude 9, 19, 53; *60–61*
Creed, Martin 8; *8*
Cruikshank, Damian 20, 53; *66–67*
Cutts, Susan 7, 91; *6, 92*

Dawson, Sophie 18
Degener, Amanda 122

Farmer, Jennie 25, 33; *39*
Farrow, Carol 18; *18*
Floderer, Vincent 9, 19, 53; *1, 9, 58–59*
Fuse, Tomoko 20, 53; *64*

Gentenaar, Peter 119
Georgeot, Alain 28
Gibbs, Dave 121
Gray, Nicola *44–45*
Griffiths, Brian 15
Guilleminot, Marie-Ange *30*
Gumuchdjian, Philip 21, 121

Harbin, Robert 28, 65
Hatakeyama, Norie 91; *100–01*
Hay, Graham 16, 25, 33; *17, 36*
Heughan, Chrissie 121
Holmes, Cas 33; *46–47*
Howell, Douglass Morse 13, 17
Hunter, Dard 17, 123, 124

Ibe, Kyoto 91, 121; *108–09*
Ida, Shoichi 121
Ito, Kei 21; *20, 104–05*

Jackson, Paul 9, 19, 27–31, 53; *8, 26, 62–63*
Jaffe, Jeanne 91; *93*

Jaycock, Carl 25, 33; *40–41*
Johnson, Paul 69; *86–87*
Joisel, Eric *57*

Kaikkonen, Kaarina *106–07*
Kawamura, Tetsuji 69; *80–81*
Keyte, Julia 22; *79*
Kondon, Tomie 121
Koretsky, Donna 124
Koretsky, Elaine 124
Kunito 121

Lane, Sue 22, 23, 91; *102–03*
Lucchesi, Paola 117

Manheim, Julia 16, 22; *15, 22*
Miyake, Issey 21, 30
Muhlert, Karin 91; *96–97*

Nash, Catherine 117, 123
Niczewski, Peter 69; *76–77*

O'Kelly, Angela 22; *98–99*

Parry, Jacki 17, 18, 19, 33; *18, 34–35*
Picasso, Pablo 16, 21

Richardson, Maureen 122
Rindl, Deb 25, 33; *42–43*
Robinson, Brian *50–51*
Robinson, Ivor 121
Rush, Peter 24

Shimura, Asao 119
Spence, Steven 21
Stanley, Andrea 25, 33; *14, 37–38*
Stockwell, Susan 15

Thomas, Charlie 21, 22, 69; *70–73*
Torley-Gentenaar 119
Turner, Sylvie 17
Tyler, Ken 17
Tyson, Matthew *48*

Ulbricht, Gangolf 117

Walpole, Jess 69; *78*
Weber, Therese 120
Wilson-Hart, Alison 22, 69; *74–75*

Yoshizawa, Akira 19, 20, 28, 53; *19, 54–56*